The 1980s
Ireland in Pictures

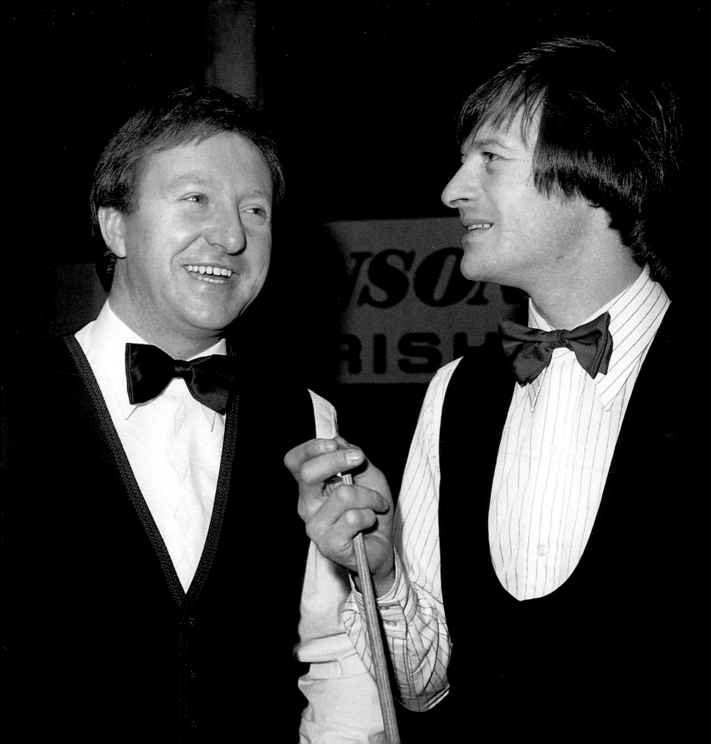

The 1980s
Ireland in Pictures

Lensmen Photographic Archive

THE O'BRIEN PRESS
DUBLIN

Opposite
Two world champions from Northern
Ireland: Dennis Taylor and Alex 'Hurricane'
Higgins at the Benson & Hedges Irish
Masters snooker tournament at Goffs, Kill,
County Kildare. After making it through to
the final several times, Higgins finally won
the tournament in 1989.

1 May 1980

First published 2014 by The O'Brien Press Ltd.,
12 Terenure Road East, Rathgar,
Dublin 6, Ireland.
Tel: +353 1 4923333; Fax: +353 1 4922777
E-mail: books@obrien.ie
Website: www.obrien.ie

ISBN: 978-1-84717-321-8

6 5 4 3 2 1
17 16 15 14

Printed and bound by GraphyCEMS, Spain
The paper used in this book is produced using pulp from managed forests

Acknowledgements: It would not have been possible to put this book together
without the help of the following: Susan Kennedy, Sean Walsh, Tara Keown,
Jill Quigley, PJ Maxwell, Mark Siggins, Anthony McIntyre, Jamie Ryan, Harry
Garland, Mary Patricia Gallagher, Philip White and Julian Seymour. Thanks also
to all those who have worked in Lensmen over the past sixty years.

The O'Brien Press would like to thank Mary Webb for her contributions to these
and so many other books.

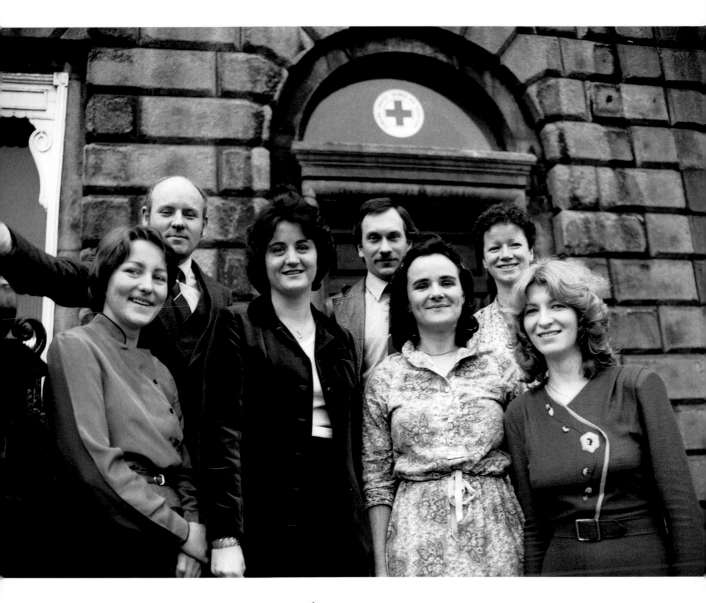

An Irish Red Cross Society/Cumann Croise Deirge hÉireann medical team at the Society headquarters in Dublin, in advance of a humanitarian mission to Kampuchea (Cambodia) and Thailand. From left: Anne Hickey, Dr Pat Donohoe, Patricia Tobin, Michael McCarthy, Bridget Lyons, Philomena Mulligan and Katherine Hyland.

29 February 1980

Victory celebrations at the sixteenth National
Song Contest. Shay Healy (left), who wrote
the winning song 'What's Another Year',
with singer Johnny Logan and compère Larry
Gogan (right), at RTÉ Montrose, Dublin.

9 March 1980

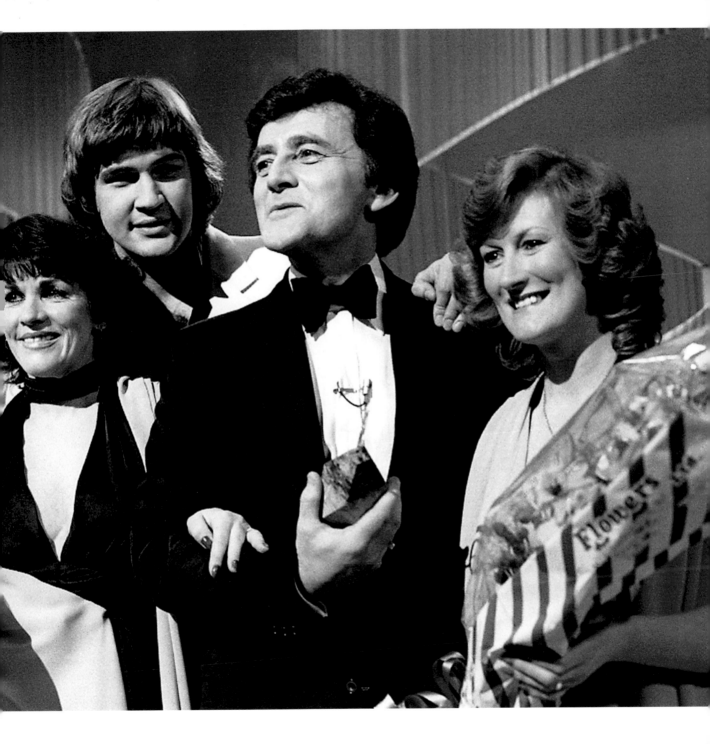

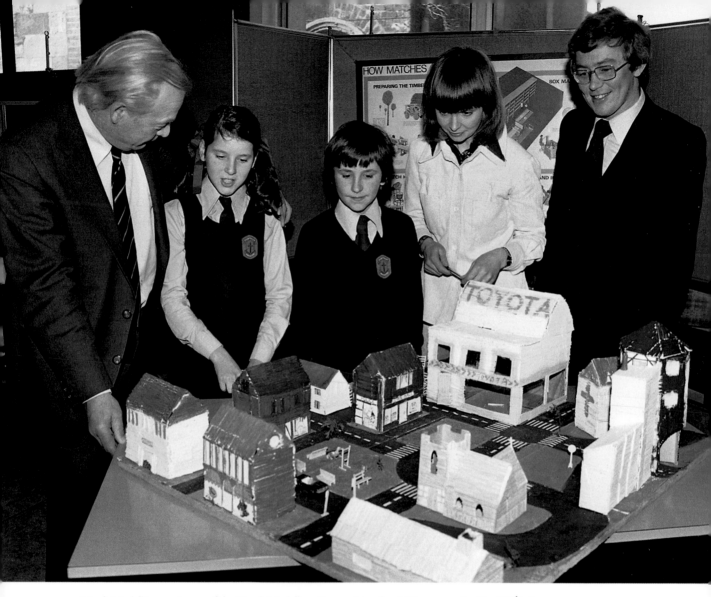

Match Modelling – winners of the Match Modelling Competition for children, organised by RTÉ's *Poparama* programme and sponsored by Maguire & Paterson, during a visit to the Maguire & Paterson factory. Left to right, looking at the winning group entry: Alan Buttanshaw, MD of Maguire & Paterson; Sheila Hughes and Rodney Chichignoud, from St Colmcille's National School, Templeogue, Dublin; Ruth Buchanan, presenter of *Poparama*; and Paul Dalton, teacher at St Colmcille's NS. The winners were then treated to a luncheon in Dublin Zoo.

7 March 1980

The Eighties

Though it was not so long ago, the world was a very different place in the 1980s. It will certainly be remembered for bad haircuts – perms for ladies, mullets for gents – and worse fashions – can anyone think of leg warmers and shoulder pads without a shudder? We cried in front of *Dallas* and *Dynasty* on our television screens, and cried in frustration over the Rubik's Cube.

It was a high-tech age. The personal computer was born, and the ultimate modern accessory was the Sony Walkman. In early 1981, the first space shuttle, *Columbia*, took off, and in Dunmurry, southwest Belfast, John DeLorean unveiled his revolutionary, though short-lived, space-age sports car.

Meanwhile, the Cold War ended and the Berlin Wall came down, and everyone breathed a sigh of relief that nuclear Armageddon was not, after all, imminent.

Politicians of the era seemed to come from the world of fiction – Ronald Reagan, straight from the silver screen, and on this side of the pond, Gaelic smooth talker and chancer Charles Haughey versus the Iron Lady, the austere and severe Margaret Thatcher.

In 1981, ten hunger strikers, including elected Westminster MP Bobby Sands, starved to death in the Maze prison in Belfast, sparking off rioting in Dublin and elsewhere.

That same year, the Stardust nightclub burned down, and forty-eight young people tragically lost their lives.

Severe economic recession spread across most of the globe in the early part of the decade, and emigration picked up in Ireland again, with up to 40,000 people leaving the country in each year of the 1980s.

The British government officially recognised the right of the Irish government to a say in Northern affairs, as Garret FitzGerald and Margaret Thatcher hammered out the Anglo-Irish Agreement of 1985.

Devastating famine hit Ethiopia, and Bob Geldof's Live Aid concerts were organised in 1985 to help raise awareness and funds.

There was a wave of kidnappings throughout the 1980s, including those of Galen Weston, Jennifer Guinness and John O'Grady; and senior forensic scientist Dr Jim Donovan was seriously injured by a bomb placed in his car, presumed to be the work of Dublin crime boss Martin Cahill, 'The General'.

On the political front, the decade saw huge advances for Tomás MacGiolla's Workers' Party, which included among its ranks Proinsias De Rossa, Pat Rabbitte and Eamon Gilmore. December 1985 saw the birth of a new political party – Des O'Malley's Progressive Democrats, including star players Michael McDowell and Mary Harney.

In 1986, Hurricane Charlie wreaked havoc, severely flooding the River Dodder in Dublin.

The snooker world was swept by another hurricane, as Alex 'Hurricane' Higgins and Dennis Taylor reigned at the snooker table. Meanwhile, Jack and his Army put the opposition under pressure on the soccer pitch, Shergar took the racetrack by storm, and Stephen Roche won the Tour de France in another kind of saddle.

Ireland was kept entertained by the likes of Maureen Potter, Brendan Grace, Gay Byrne, Noel Purcell, Tony Kenny, The Dubliners, Thin Lizzy and U2, while Johnny Logan won an astonishing two victories at Eurovision.

The decade featured some big anniversaries for Irish towns: Galway city celebrated its 500th birthday in 1984, and Cork its 800th in 1985. Not to be outdone, Dublin celebrated its Millennium year in 1988, and then Dundalk topped the lot with its 1200th birthday in 1989.

The powerful, quirky, moving, funny and celebratory images in this book provide a revealing glimpse into a momentous decade in Irish life.

Eoin O'Brien

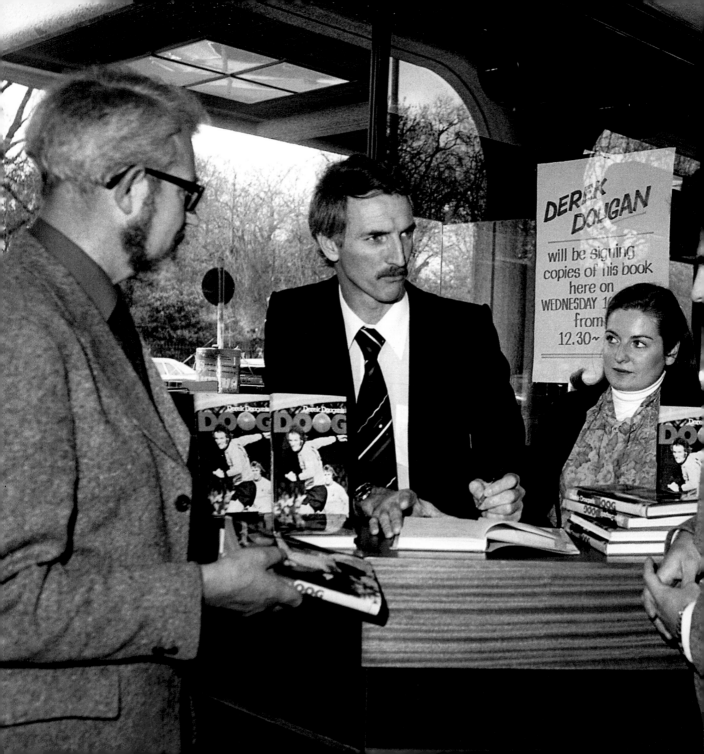

DEREK
DOUGAN

will be signing
copies of his book
here on
WEDNESDAY 1
from
12.30~

One of the most flamboyant and controversial heroes in the history of soccer, Derek Dougan signs copies of his autobiography, *Doog*, for customers at Hodges Figgis, Stephen's Court, Dublin. Photo shows one of the first customers, Peter Moynihan of Sandyford, County Dublin, as well as Robert Twigg, Manager, Hodges Figgis, and Norma Doyn, cashier.

16 April 1980

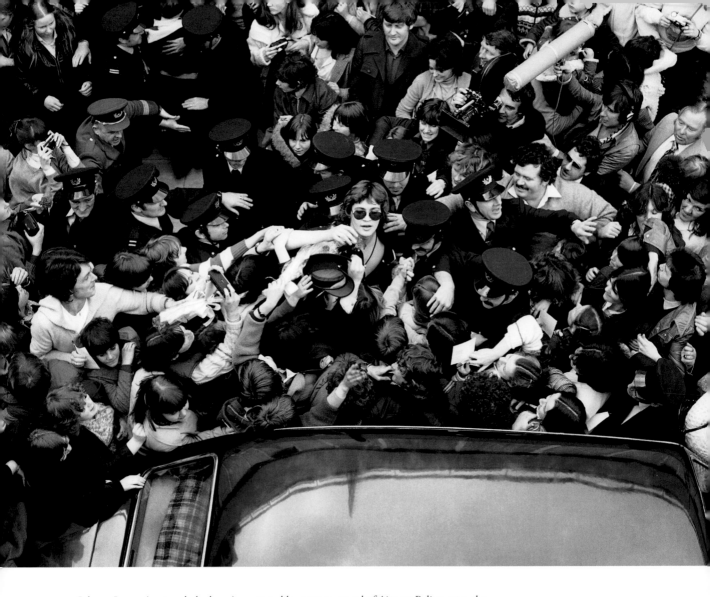

Johnny Logan (centre, dark glasses), protected by a strong guard of Airport Police, struggles to reach his car through a mob of teenagers at Dublin Airport, on arrival from victory at the Eurovision Song Contest in Holland.

21 April 1980

The photographers: Lensmen

Andrew Farren and Pádraig MacBrian were both staff photographers in the *Irish Press*. Pádraig recalls that his first press photo was of cattle being loaded onto a ship on Dublin's South Wall. At the time, his wages were £1 a week!

In 1952, still only in their twenties, the pair set up Lensmen as a commercial news photographic service, initially in rented offices in Westmoreland Street, Dublin. They covered major news stories for British national newspapers and for the Cork Examiner. By the early 1960s business had expanded substantially, with Lensmen having the agency for all major Irish government departments, as well as working for PR companies and commercial businesses. They bought Nos. 10 and 11 Essex Street, and called it Lensmen House. This developed into a major agency, employing fifteen people, including five photographers. Interestingly, one of their jobs was to take photos of Irish life and events for the Irish editions of British newspapers to replace their 'Page 3 Girl' pictures, which were not considered suitable for Irish readers!

Among the stand-out events they covered were the visit of President Kennedy in the '60s and that of Pope John Paul II in 1979. Andy remembers the excitement of being on board one of the US press helicopters going to the Kennedy ancestral home in Dunganstown in 1963.

A key development for the business was the purchase of a wire machine that could transmit photos over the telephone. This was used extensively during the period of Jack Lynch's government, including the fallout from the Northern Troubles.

In the early days they used Linhof cameras with glass plates, both 9x12cm and the US standard 5x4ins. These plates survive in today's Lensmen, run by photographer Susan Kennedy, who bought the business in 1995. The meticulously recorded Lensmen archive includes a record of each day's photographic assignment as well as details of the shoot, making it a valuable visual history resource.

Andrew Farren Pádraig MacBrian

This book is dedicated to Andrew Farren and Pádraig MacBrian, photographers and founders of Lensmen, for the excellence and accuracy of their work.

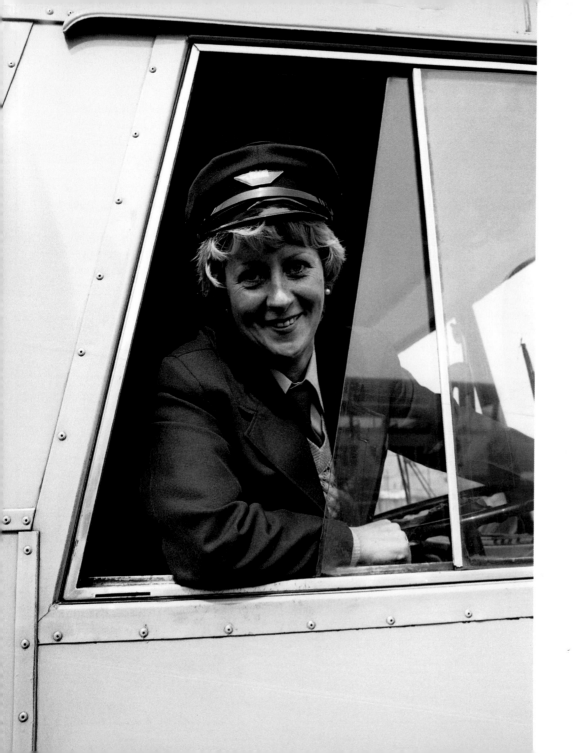

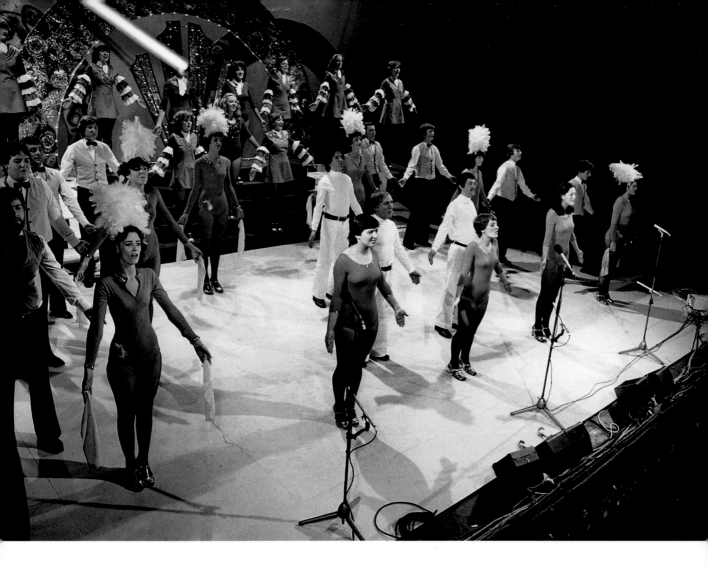

Joan Doran of Ballyfermot, Dublin,
CIÉ's first-ever female bus driver,
photographed at Phibsborough Garage,
Dublin, as she sets off on her first round.

2 May 1980

Performers in the John Player 'Tops of the Town' final, at the
Gaiety Theatre, Dublin. The Irish Distillers Variety Group
ultimately emerged as the winner, beating Waterford Banks
and Finance by two marks.

1 June 1980

Mark Killilea TD, Minister of State at the
Department of Posts and Telegraphs, opens the new
automatic exchange at Kilronan on Inismore.

20 June 1980

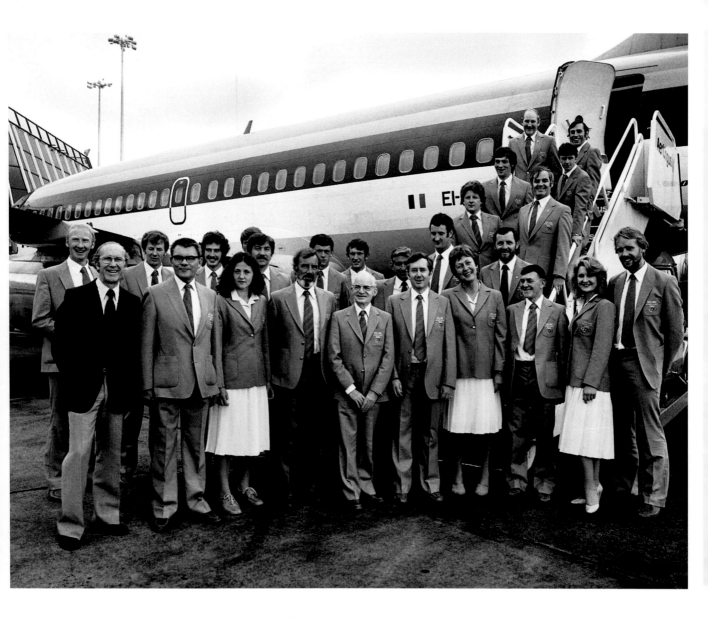

Olympian ambition: part of the Irish team, with their Chef de Mission and officials, leaving Dublin Airport bound for the Olympic games in Moscow.

14 July 1980

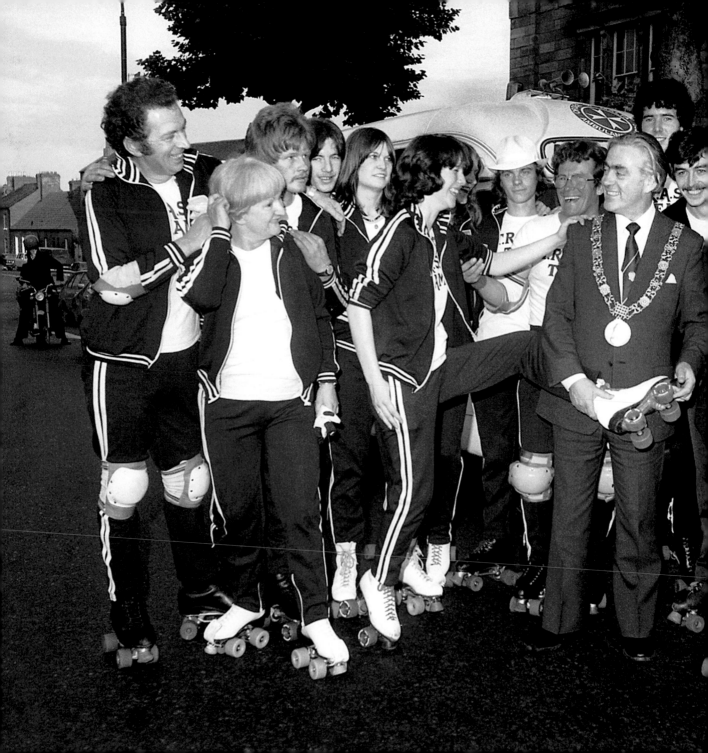

Members of the Roller All Star Hockey Club assemble outside Kilmainham Jail, Dublin, before setting out on a non-stop roller skating marathon from Dublin to Cork to raise money for the Central Remedial Clinic. Dublin's Lord Mayor, Fergus O'Brien, inspects their equipment before they leave. On the right is Senator Lady Valerie Goulding, Chairperson and Managing Director of the CRC.

15 August 1980

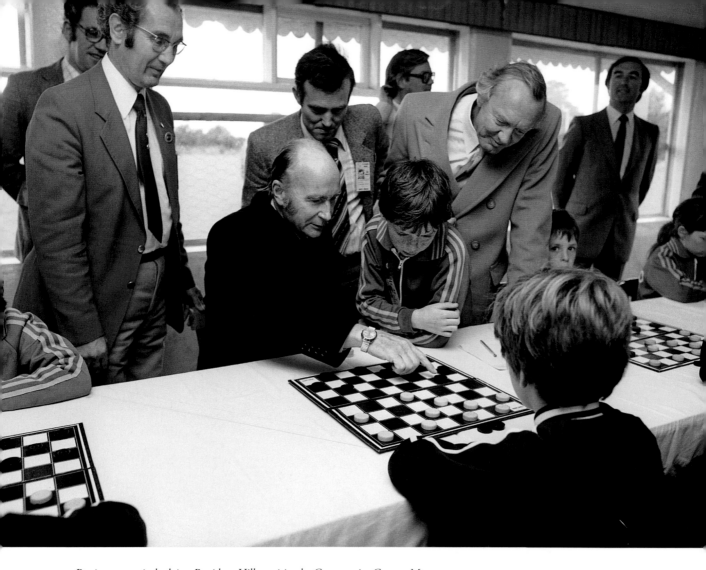

Passing on tactical advice: President Hillery visits the Community Games, Mosney, County Meath.

13 September 1980

Calls to the Bar: newly qualified lawyers at the Four Courts, Dublin. (l–r:) Paul Carney, Rathmines, Dublin; Peter Sutherland, Blackrock, Dublin; Frank Spain, Lansdowne Road, Dublin; John D Cooke, Churchtown, Dublin; David Montgomery, Blackrock, Dublin; and Eoghan Fitzsimons, Howth, Dublin.

6 October 1980

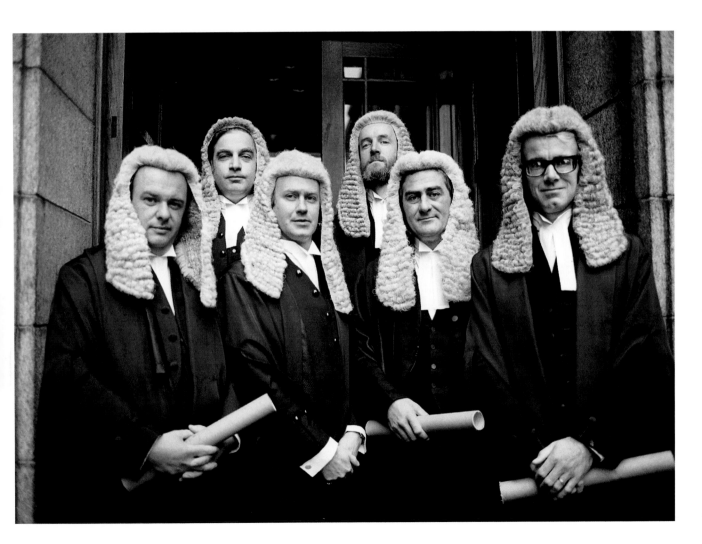

Fresh faces at the eighteenth annual Notres Dames des Missions Debutantes Ball, at Jury's Hotel, Dublin. (l–r:) Miss Emer Fannin, Templeogue, Dublin, with Ted O'Sullivan; Miss Fiona Daly, Ardilea, Dublin, with Ronan Hannigan; and Miss Maria Gahan, Stepaside, County Dublin, with Philip O'Connor.

15 November 1980

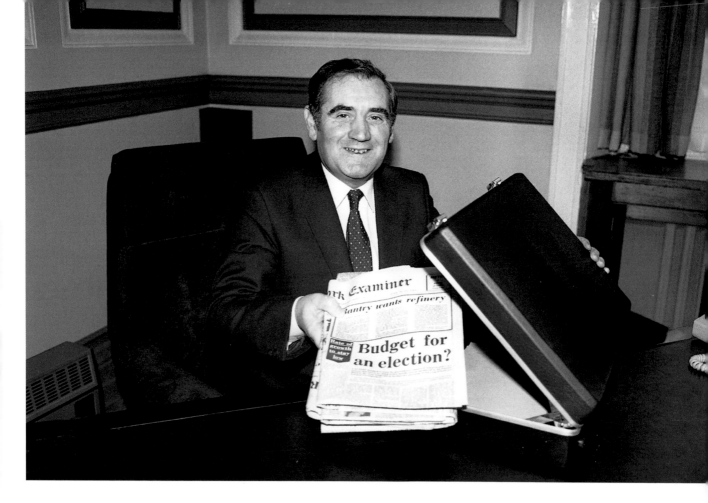

About to put an end to all the speculation: Minister for Finance
Gene Fitzgerald TD puts his copy of the *Examiner* into his budget bag at
the Department of Finance, before going to the Dáil.

28 January 1981

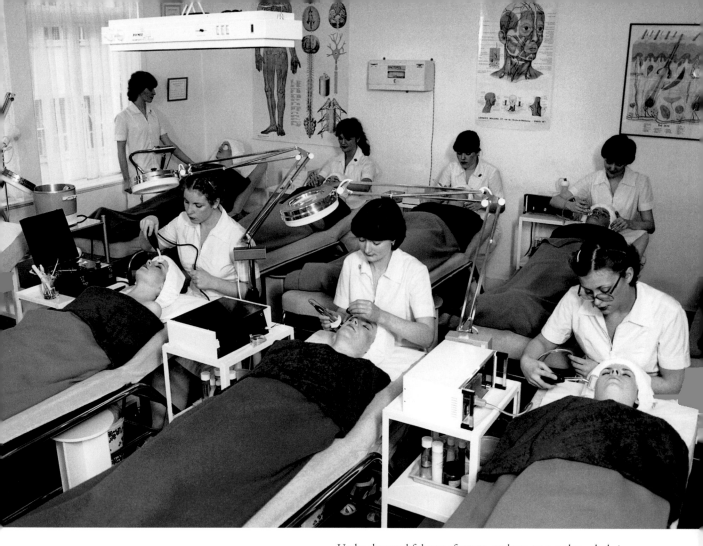

Opposite
Patrick Power TD, Minister for Fisheries and Forestry, congratulates Kathleen Ní Cheallaigh from Helvick, County Waterford, on receiving her skipper's ticket. Following a Bord Iascaigh Mhara skipper's course, held in her home port, Kathleen is qualified to command a fishing vessel up to seventy-five feet in length. Kathleen works with her brother Padraig on the fishing boat *Sinead* in Helvick.

3 February 1981

Under the watchful eyes of tutors, students are put through their paces at the Bronwyn Conroy Beauty School, 40 Grafton Street, Dublin. Established in 1971, educational certificates from the school are recognised throughout the beauty world.

6 February 1981

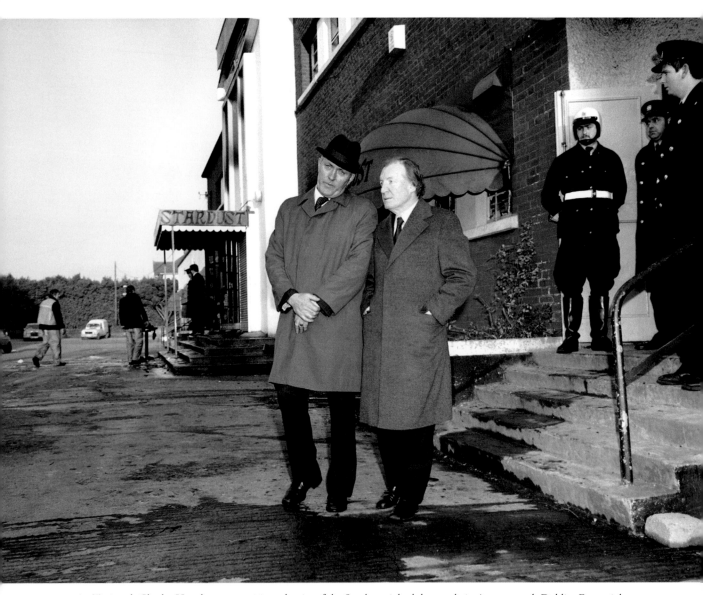

An Taoiseach Charles Haughey pays a visit to the site of the Stardust nightclub tragedy in Artane, north Dublin. Forty-eight young people died and 214 were injured when the nightclub was engulfed in flames. It was widely reported that fire exits were chained shut, trapping victims inside the blaze.

14 February 1981

The burnt-out shell of the Stardust nightclub.

14 February 1981

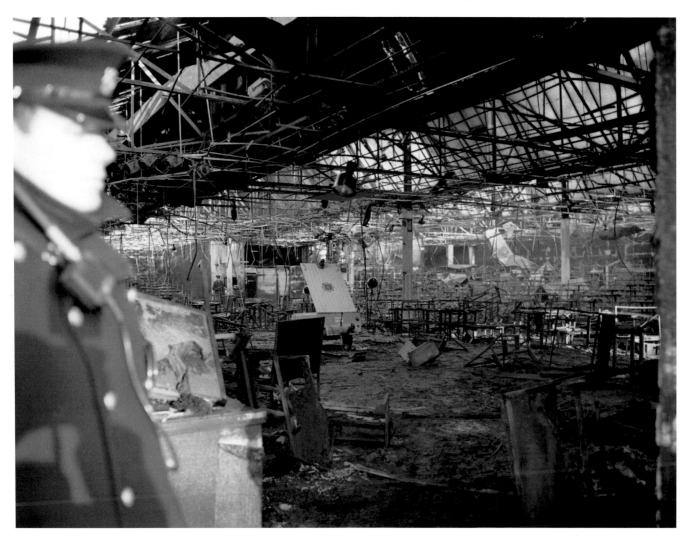

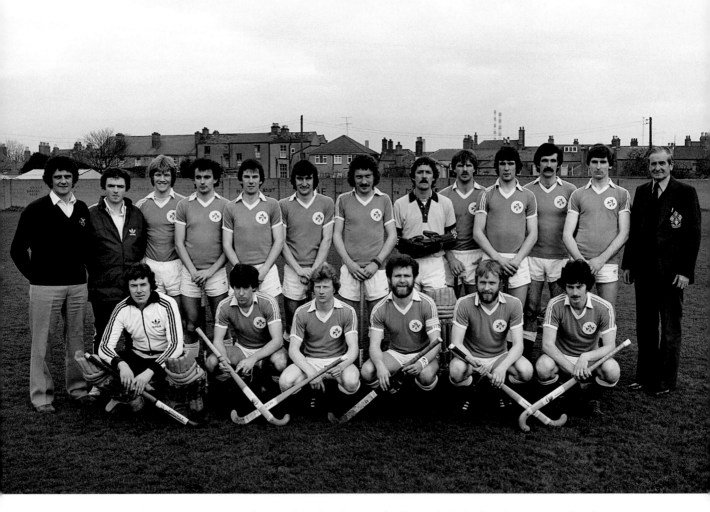

Prior to their forthcoming international against Poland, and a tour of Malaysia, the Ireland hockey team were kitted out in a full set of Adidas gear by the Great Outdoors camping shops. The squad includes: T Allen, A Carson, C Allister, M Burns, J Cole (Captain), E Cummins, R Haughton, D Richardson, J Kirkwood, N Crawford, W McConnell, J McKee, S Martin, A O'Driscoll, Ian O'Keeffe and P Hardy. Also in the picture are Joey O'Meara, coach to the team, D Balbernie, team manager, and (extreme right) FA Glasby, President of the Irish Hockey Union.

16 March 1981

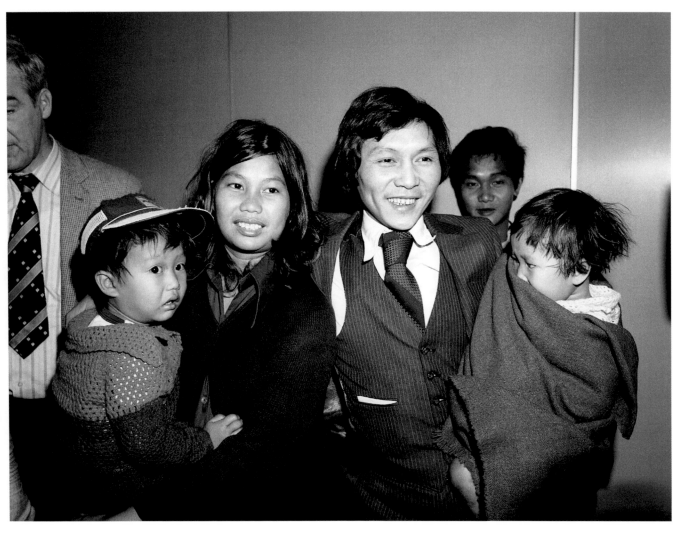

As part of a resettlement plan initiated by the United Nations, Ireland agreed to welcome a number of Vietnamese families displaced by the Vietnam war. Here, Mr Nga Van Thai, his wife and two children arrive at Dublin Airport, as part of a group of seventeen who hoped to settle here.

18 March 1981

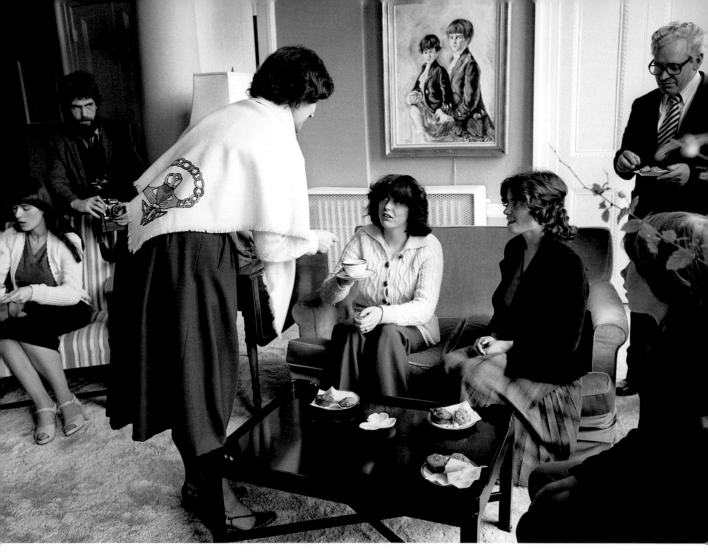

Opposite
Mrs William Shannon, wife of the American Ambassador to Ireland (centre, wearing a Galway shawl), hosts a group of Galway travelling people for afternoon tea at her residence in the Phoenix Park, Dublin. Included are Rose Corcoran, Ann Sherlock, Brigid McDonagh and Ann Ward.

1 April 1981

Eurovision Song Contest winners Buck's Fizz are congratulated
by Irish entrants Sheba.

5 April 1981

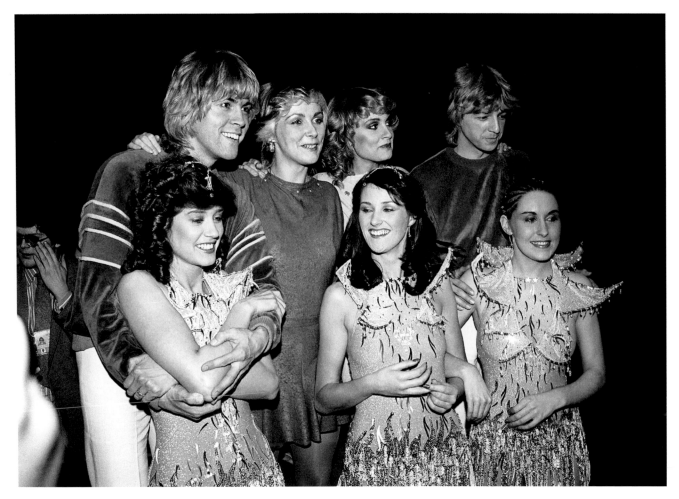

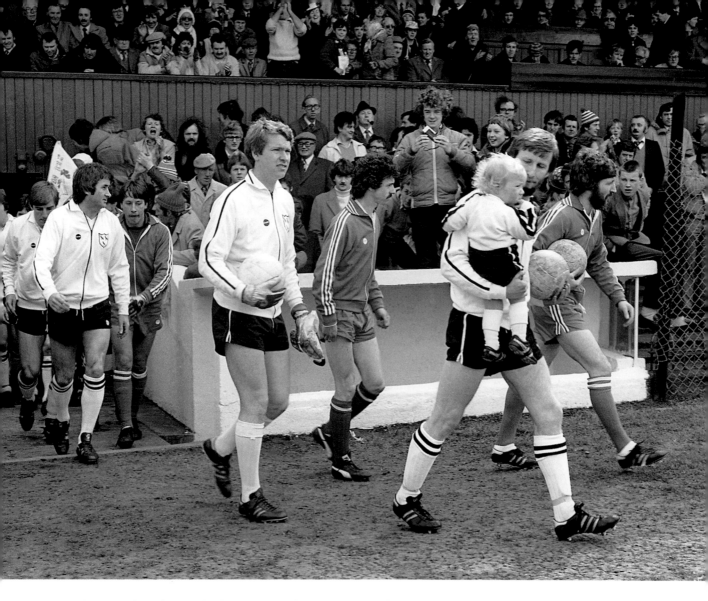

The teams take to the pitch for the FAI Cup Final. In the event, Dundalk beat Sligo Rovers 2–0. The winning goals were scored by John Archbold and Mick Fairclough.

26 April 1981

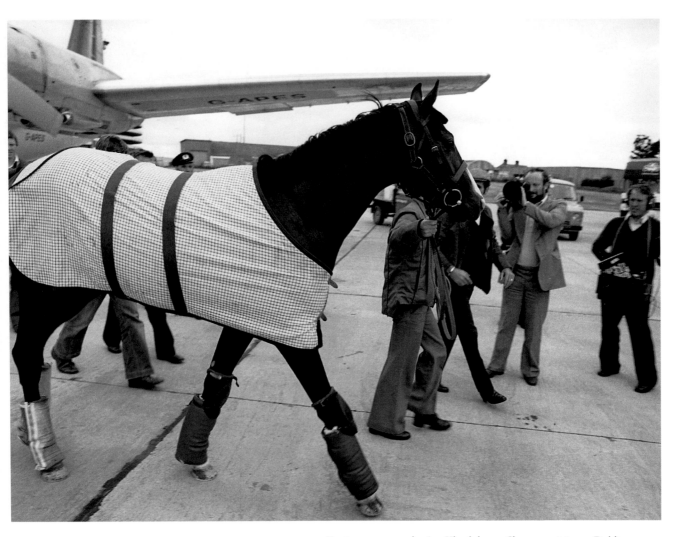

Equine superstar: the Aga Khan's horse, Shergar, arriving at Dublin
Airport, en route to the Sweeps Derby at the Curragh, County Kildare.

25 June 1981

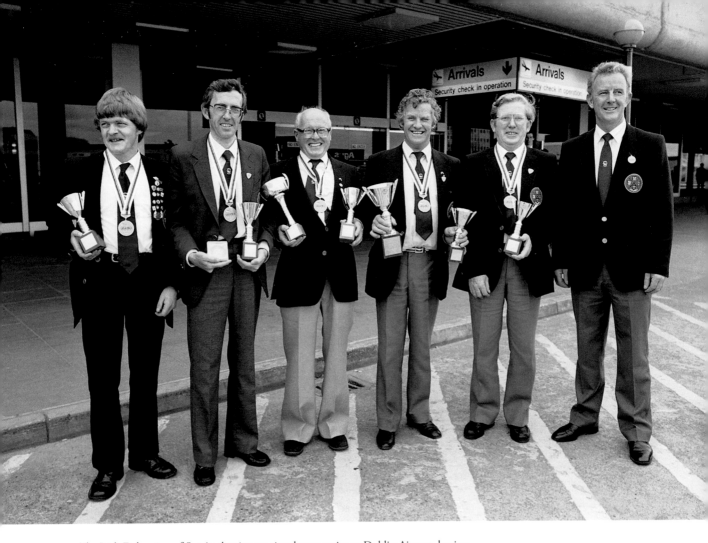

The Irish Federation of Sea Anglers international team arrive at Dublin Airport, having come third in the World Championships at Heligenhafen, West Germany. (l–r:) Michael Butler, Dunmore East Sea Angling Club; Alan McKeown, Ballymena Sea Angling Club (joint winner of the heaviest fish award); Willie McGonigle, Enniscrone Sea Angling Club (tenth in Individual Contest); Ted Geary, Monkstown Sea Angling Club; Jack Johnson, Celtic Sea Angling Club; and Padraic Conlon, Westport Centurion Sea Angling Club.

30 June 1981

The newly elected Fine Gael/Labour coalition government under Dr Garret FitzGerald, having received their seals of office from President Hillery at Áras an Uachtaráin. Back row: Minister for Finance, John Bruton; Minister for Fisheries and Forestry, Tom Fitzpatrick; Minister for Labour and Public Services, Liam Kavanagh; Minister for Agriculture, Alan Dukes; Minister for Justice, Jim Mitchell; Minister for Posts and Telegraphs and Transport, Patrick Cooney; Minister for Trade, Commerce and Tourism (also acting Minister for Foreign Affairs), John Kelly; Minister for Education, John Boland; Minister for the Gaeltacht, Paddy O'Toole; James Dooge (appointed Minister for Foreign Affairs following his subsequent nomination to Seanad Éireann).
Seated: Minister for Defence, James Tully; Taoiseach, Garret FitzGerald; President Patrick Hillery; Tánaiste and Minister for Industry and Energy, Michael O'Leary; Minister for the Environment, Peter Barry; Minister for Health and Welfare, Eileen Desmond; Attorney General, Peter Sutherland.

30 June 1981

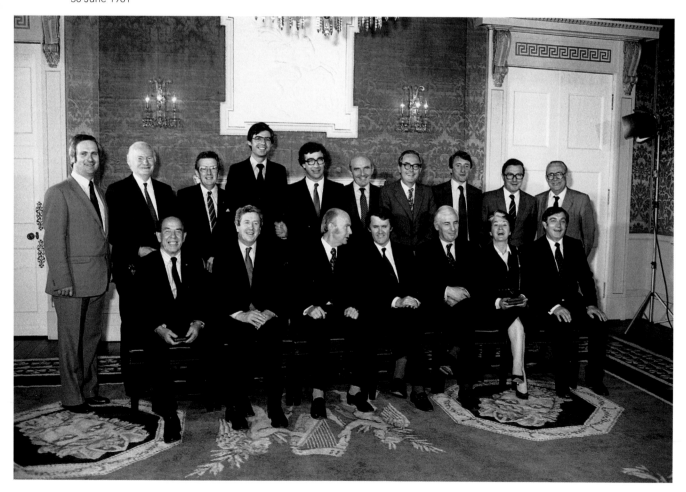

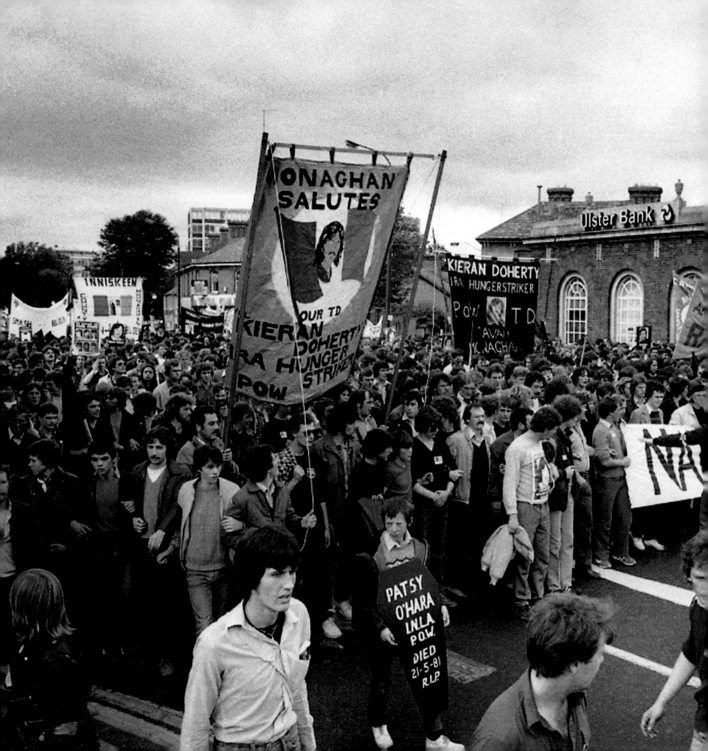

An estimated 10,000 took to the streets in Dublin in support of the republican hunger strikers in the Maze prison in Belfast. As the protest dispersed, about 500 marchers confronted an estimated 1,000 riot police at the British Embassy in Ballsbridge, and violence quickly ensued. Hundreds of office and shop windows were smashed. Ten hunger strikers ultimately died of starvation in the Maze, including elected Westminster MP Bobby Sands.

18 July 1981

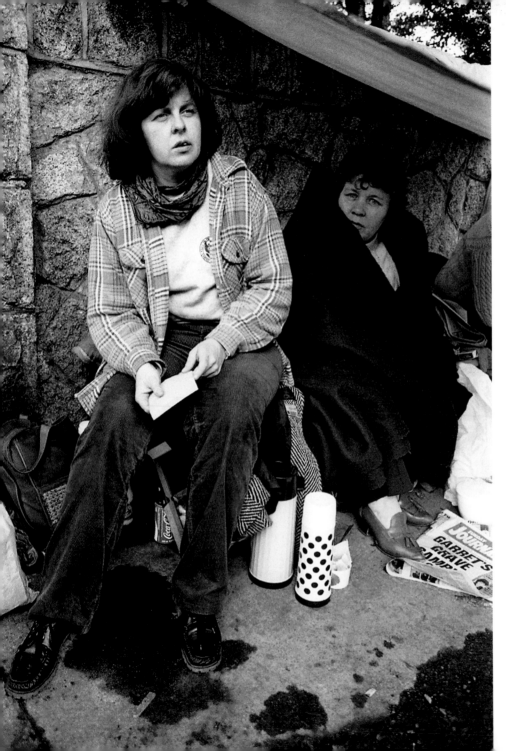

Women members of the
National H-Block Committee
who stayed outside the British
Embassy, Dublin, through
the night of Saturday 18 July,
led by Bernadette McAliskey
(left), and who were allowed
to deliver their letter to
the British Ambassador on
Sunday morning, pictured
in the make-shift tent that
they erected outside the RDS,
Ballsbridge.

18 July 1981

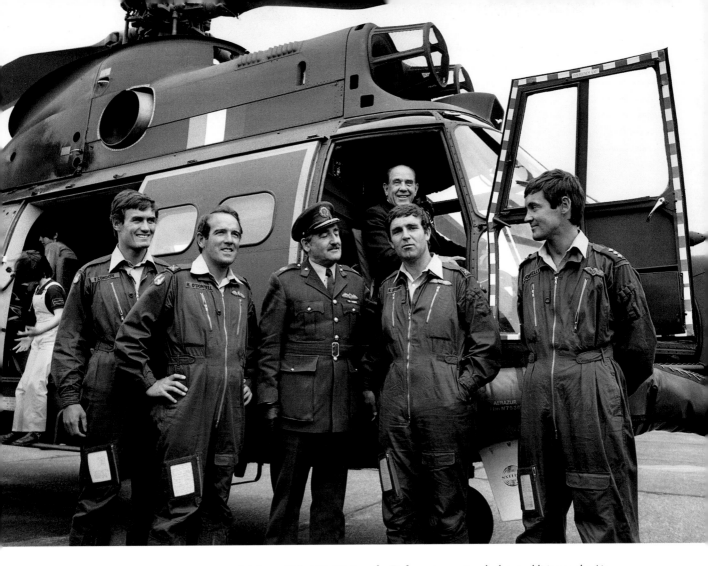

Mr James Tully TD, Minister for Defence, inspecting the latest addition to the Air Corps fleet – a French-built SA 330J 'Puma' twin-engined helicopter – at Casement Aerodrome, Baldonnell, County Dublin. Centre: Brig-General William Glenn, GOC Air Corps. Also Comdt. Hugh O'Donnell (left) and Comdt. Ken Byrne.

22 July 1981

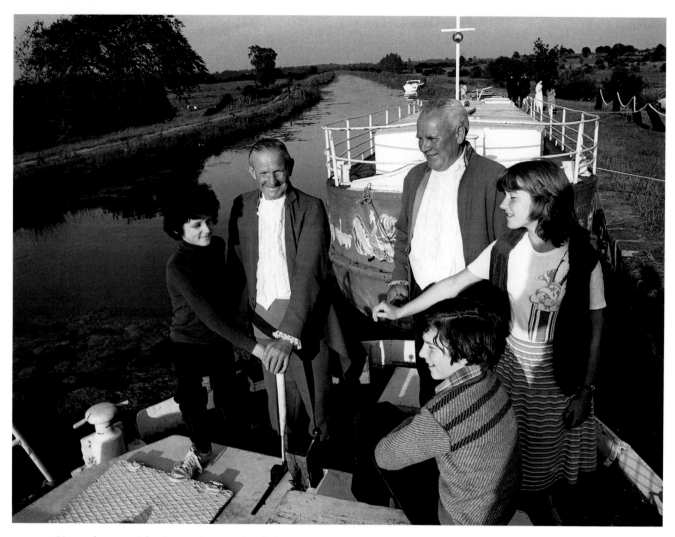

Veteran boatmen John Conroy (Lowtown) and Thomas Hannon (Robertstown) know every inch of the Grand Canal, from the old James' Street Basin to Limerick, having transported Guinness to every port of call over thirty years' employment with the Grand Canal Company. Here they give a lesson in navigation to the Porter children, Geoffrey, Jennifer and James. The occasion was a reception to announce details of the Grand Canal Festa at Robertstown, County Kildare.

31 July 1981

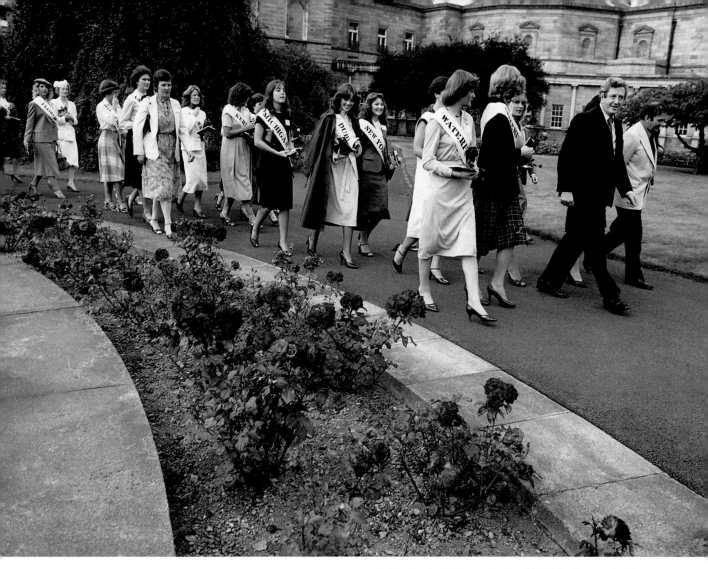

An Taoiseach, Dr Garret FitzGerald TD, leads a parade of contestants for the Rose of Tralee Festival to a reception at Government Buildings, Leinster House, Dublin, including Marian Ryan (Waterford) and Catherine O'Connor (Dublin).

28 August 1981

Former Taoiseach Charles Haughey, Noel Coade, Director, National Concert Hall Committee, and Maureen Haughey at the State opening of the National Concert Hall, Earlsfort Terrace, Dublin. The venue was officially opened by President Patrick Hillery, followed by the premier concert featuring the Radio Telefís Éireann Symphony Orchestra with a large cast of soloists, choirs and the RTÉSO leader Audrey Park, conducted by RTÉ's Principal Conductor Colman Pearce.

9 September 1981

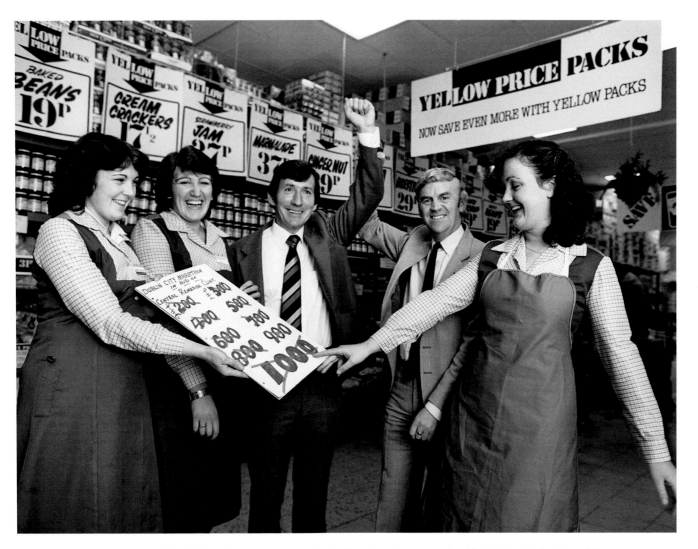

Matt Kidney, former international schoolboy boxer, is congratulated by Mr Sean Kelly, General Manager of Quinnsworth, on achieving sponsorship of £1500 for the forthcoming Dublin Marathon. The sponsorship money was donated to the Central Remedial Clinic. Also in the picture are Miriam Byrne, Ballyfermot, Bernie Byrne, Drimnagh, and Lorraine Kelly, Palmerstown.

14 October 1981

Opposite

Senator Tras Honan and Deputy Carrie Acheson, the only sisters ever to have been elected
to the Oireachtas. Senator Tras Honan (left) was elected to the Administrative Panel of the
Seanad in 1977, and re-elected in 1981. Carrie Acheson, Alderman of Clonmel Corporation,
was elected to the Dáil for the first time in June.

21 October 1981

The winner of the annual Heinz Baby of the Year Competition, with her proud parents, outside
Jury's Hotel, Ballsbridge, Dublin.

27 October 1981

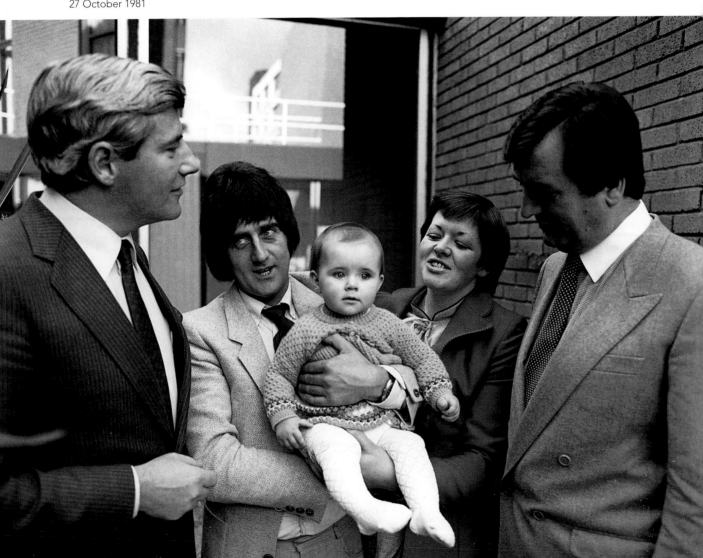

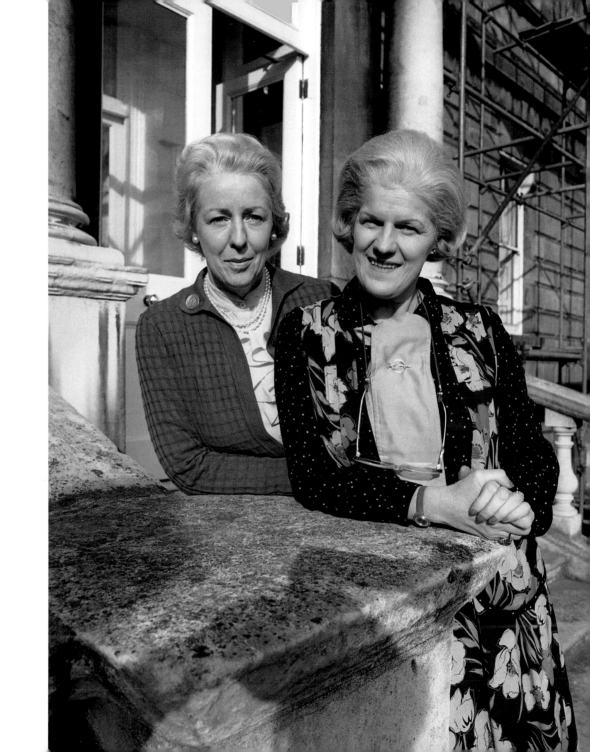

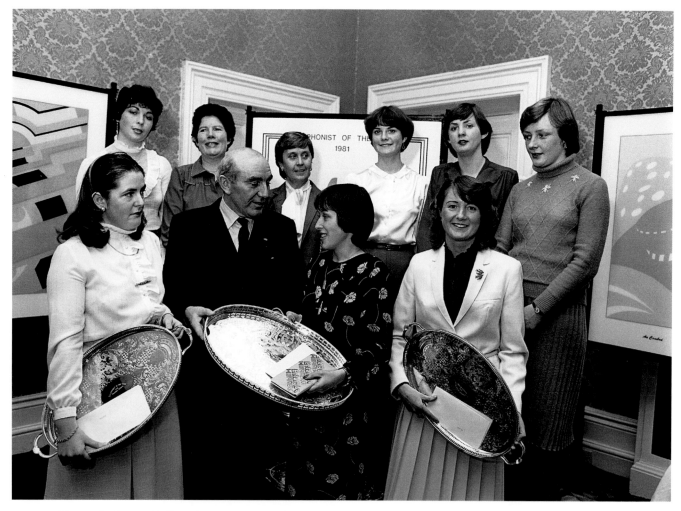

Minister for Posts and Telegraphs, Patrick Cooney TD,
presents the prizes in the Telephonist of the Year competition
at a reception in the Shelbourne Hotel, Dublin.

11 October 1981

Opposite
A new motorcycle messenger girl collecting a
Government letter for delivery.

25 November 1981

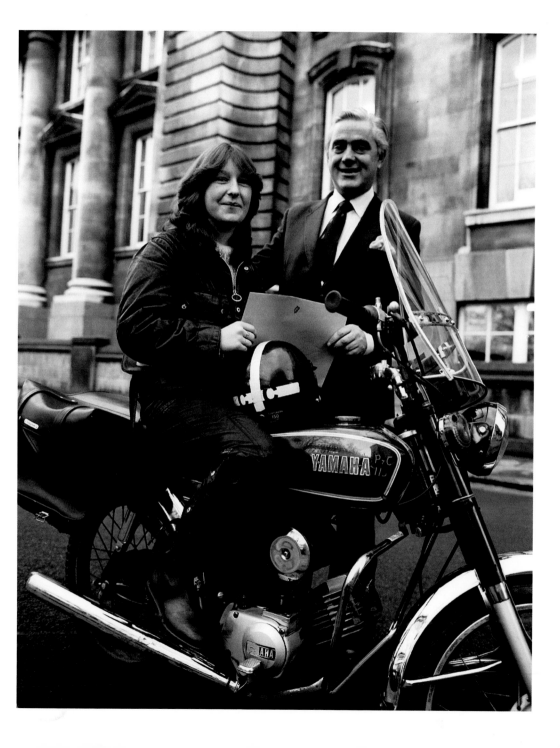

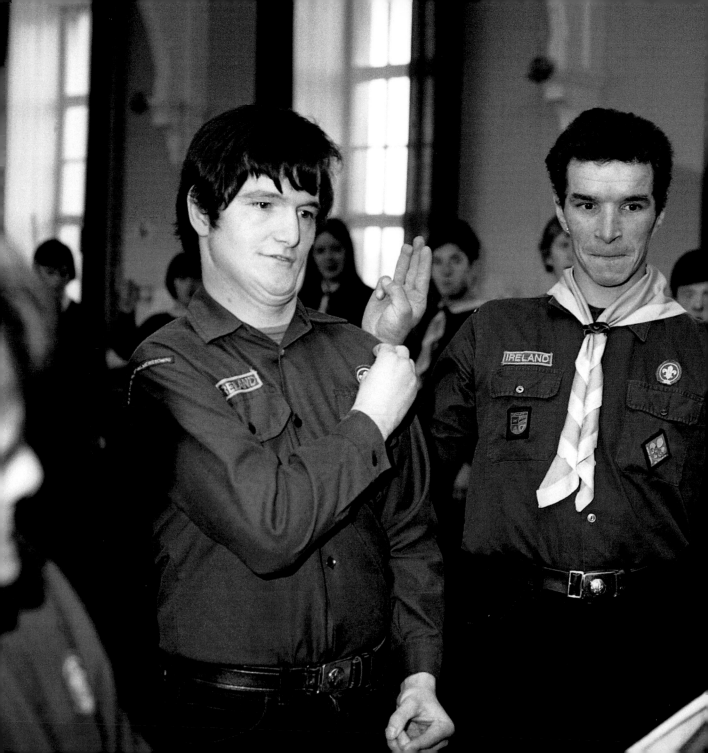

Joe Needham, a deaf and dumb resident in Stewart's Hospital, Palmerstown, County Dublin, is enrolled into the 43rd Dublin (Palmerstown) Unit of the Scouting Association of Ireland by the Chief Scout, Joe McGough. Domenica Malocca, a teacher in the class for the deaf attached to the hospital, translated the Scout Promise into sign language during the ceremony. In the photo are Joe Needham (left) and Assistant Scout Leader David Lane (right).

8 December 1981

A few friends drop by to celebrate Noel Purcell's eighty-first birthday with him in the Adelaide Hospital, Dublin. (l–r): Gay Byrne, Hal Roche, Noel Purcell and Joe Lynch, as they sing an old song from many years ago.

23 December 1981

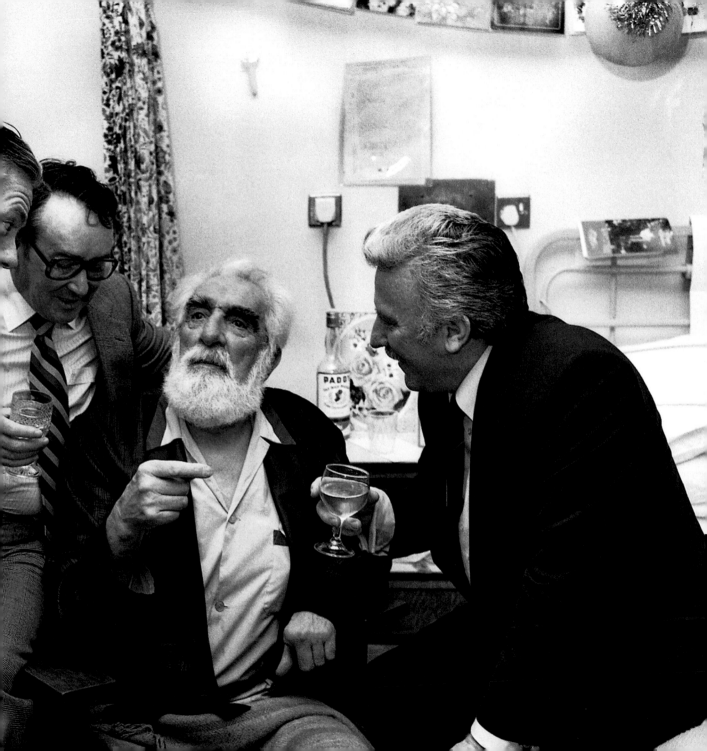

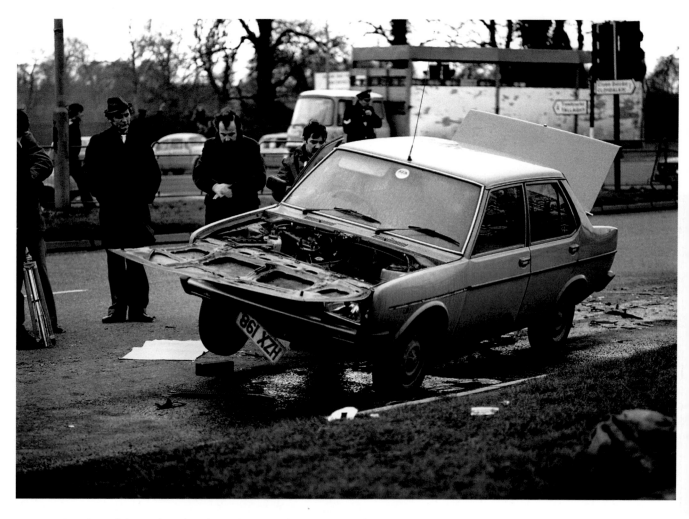

Members of the Garda Technical Squad examine the Fiat 131 that was being driven by Dr Jim Donovan when a bomb planted in the car exploded. Dr Donovan, Senior Forensic Scientist with the Garda Technical Bureau, was critically injured in the explosion at Newlands Cross, County Dublin. The bomb is believed to have been the work of Dublin criminal Martin Cahill, 'The General', as Dr Donovan was due to testify against him in an armed robbery case. Despite living in constant pain, Dr Donovan continued his work providing valuable forensic evidence to fight crime for many years after the attack.

6 January 1982

The Texaco Sportstars of the Year awards were presented by An Taoiseach Dr Garret FitzGerald TD, in the Burlington Hotel, Dublin. Recipients included (l–r): Ger McKenna, Tipperary, greyhound racing; Sean Kelly, Waterford, cycling; Jack O'Shea, Kerry, Gaelic football; and Paddy Coad, Waterford, Hall of Fame Award (soccer).

18 January 1982

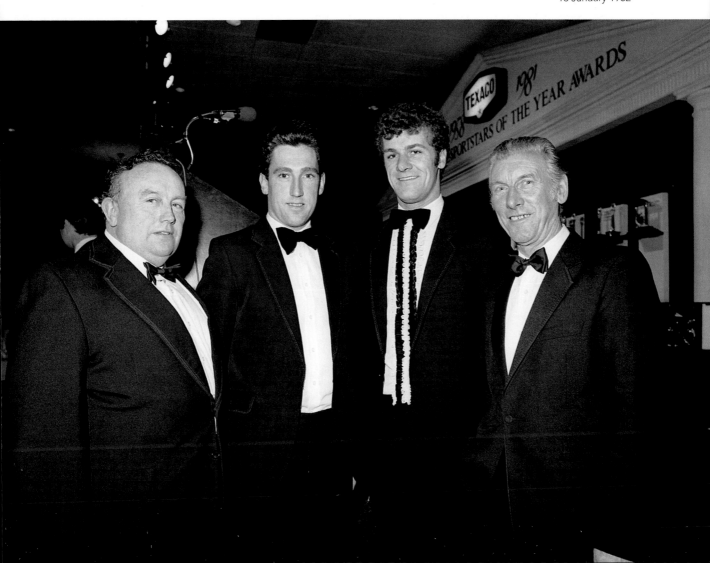

Fianna Fáil leader Charles Haughey surrounded by staff on the steps of Clonakilty County Hospital. Haughey was touring West Cork during the 1982 election campaign.

4 February 1982

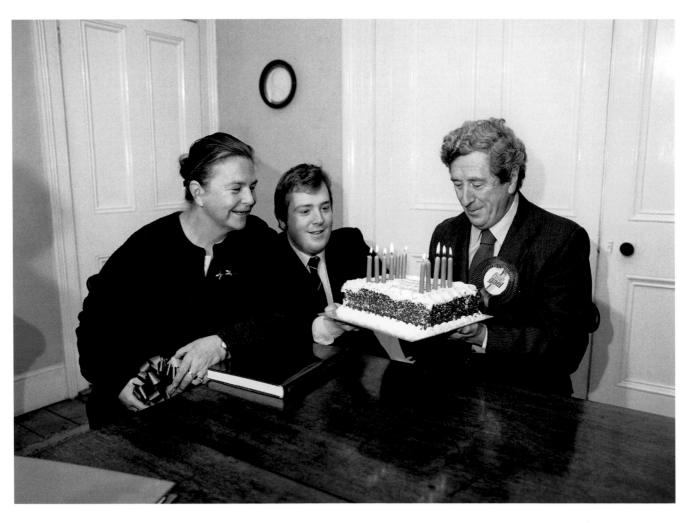

An Taoiseach Dr Garret FitzGerald TD blows out the candles on his fifty-sixth birthday cake, watched by his wife Joan and son Mark.

9 February 1982

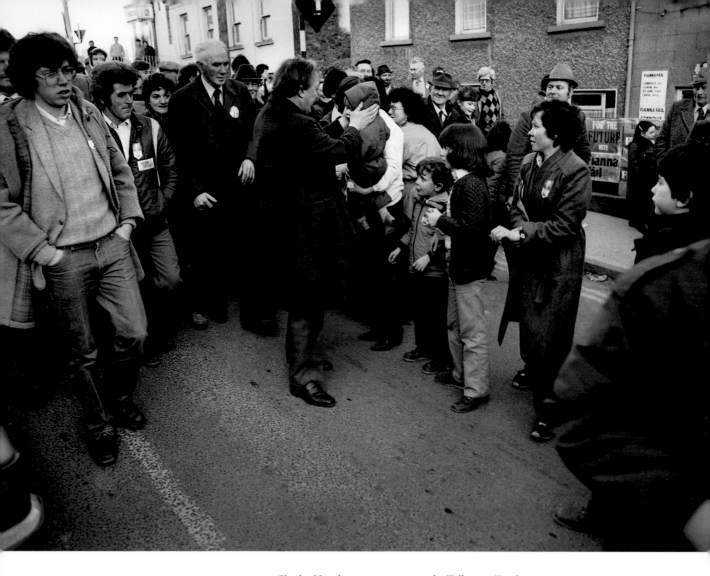

Charles Haughey campaigning in the Tullamore/Portlaoise constituency.
On the left is another future taoiseach, Brian Cowen.

14 February 1982

After a state of emergency was declared in Poland in December 1981, aid was channelled through non-governmental organisations, mainly in the form of foodstuffs and medical supplies for the poorest sections of the population. Here, Red Cross food packages are prepared for transportation.

27 February 1982

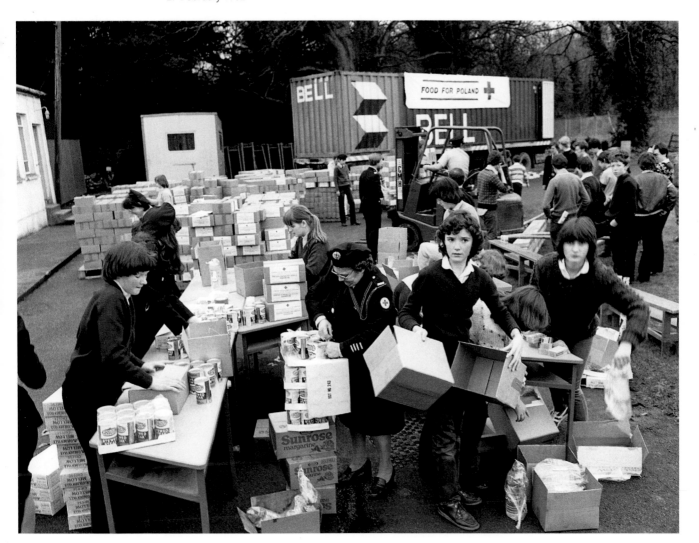

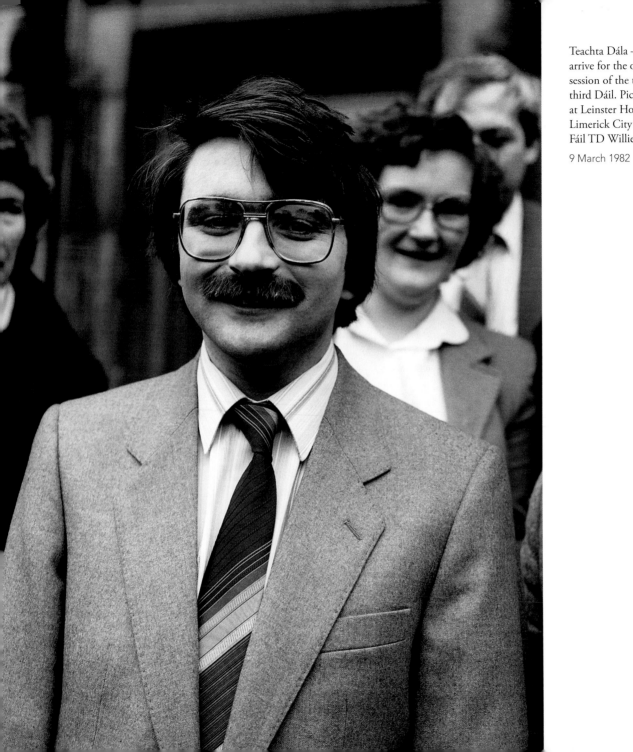

Teachta Dála – TDs – arrive for the opening session of the twenty-third Dáil. Pictured at Leinster House, Limerick City Fianna Fáil TD Willie O'Dea.

9 March 1982

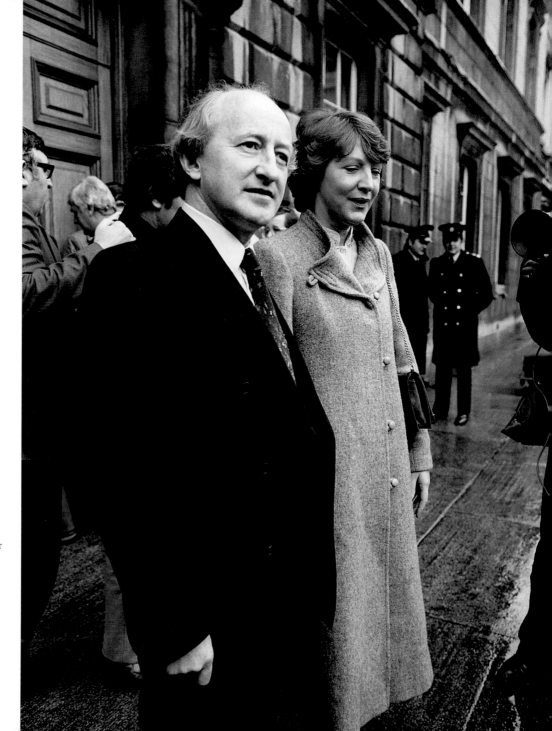

Galway West Labour
Party TD Michael
D Higgins arrives
at Leinster House,
accompanied by his
wife Sabina.

9 March 1982

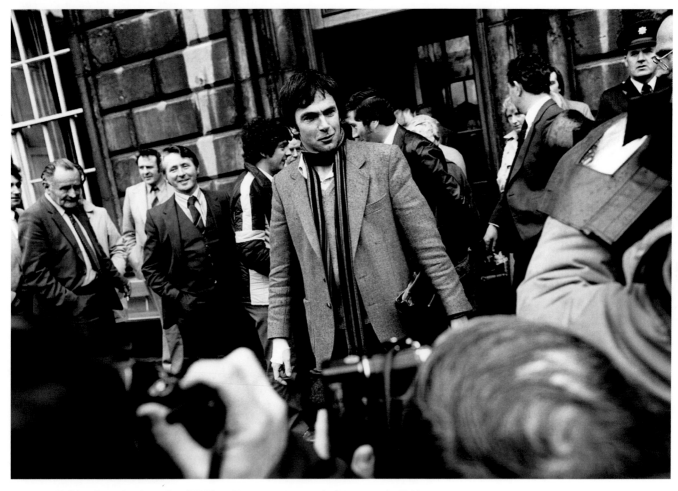

Dublin Central independent TD Tony Gregory arrives to take his seat in the Dáil.

9 March 1982

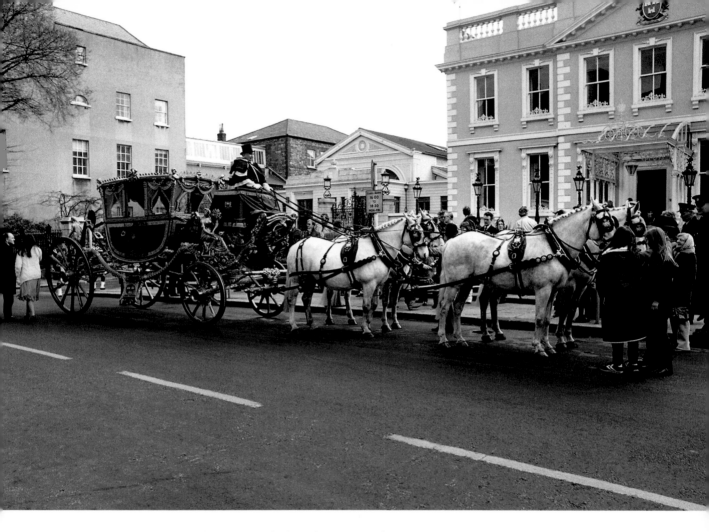

The Lord Mayor's Coach, driven by Joe McGrath, waits outside the Mansion House to take Lord Mayor Alderman Alexis Fitzgerald TD to the St Patrick's Day Parade reviewing stand in O'Connell Street, Dublin. He was accompanied in the coach by the Burgomaster of Amsterdam, Mr Willem Polak.

17 March 1982

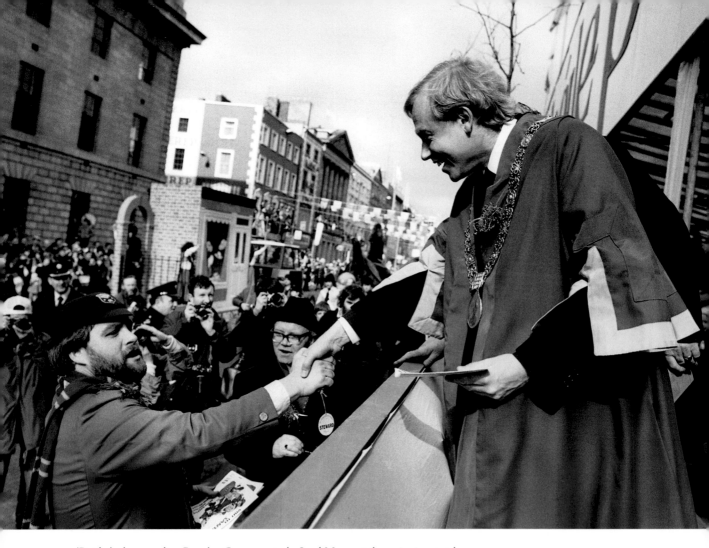

'Bottler', aka comedian Brendan Grace, greets the Lord Mayor at the reviewing stand.

17 March 1982

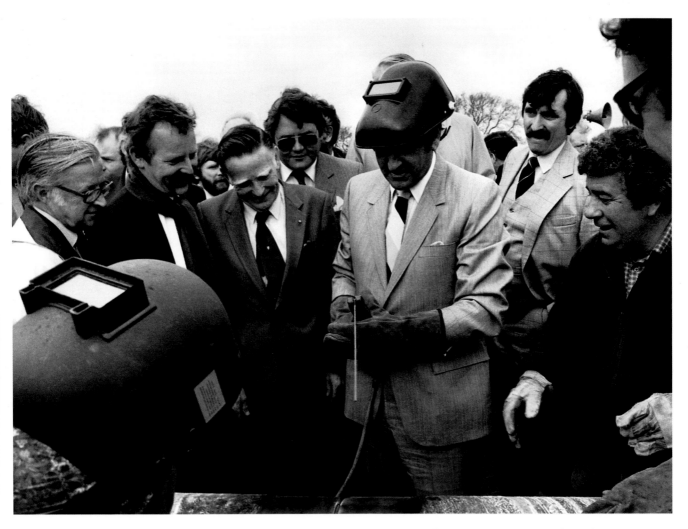

Albert Reynolds TD, Minister for Industry and Energy, performs the ceremonial first weld at Brownbarn, Kingswood, Dublin, officially starting work on the new Cork–Dublin gas pipeline.

28 April 1982

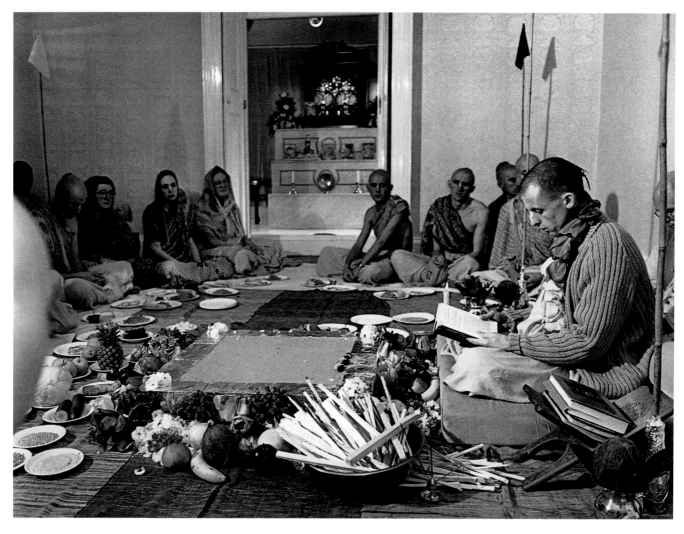

At the Hare Krishna Temple in Templeogue, Dublin, readings are held as new members prepare for initiation into the movement. The ceremony was conducted by Guru His Divine Grace, Srila Satswarupa Das Goswami.

2 May 1982

In preparation for the Central Remedial Clinic's charity 'Jogathon', television celebrity and poet Pat Ingoldsby visits children at the centre. The Jogathon would be led by eight major celebrities, including comedian Brendan Grace and rugby international Ciaran Fitzgerald.

19 May 1982

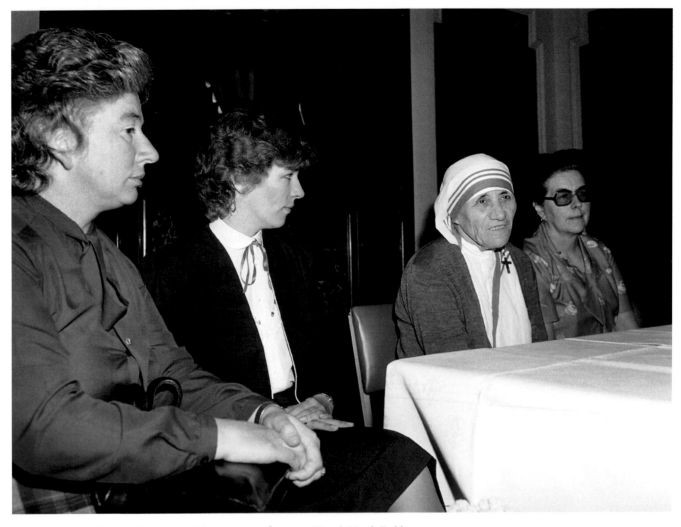

Mother Teresa of Calcutta speaks at a press conference at Wynn's Hotel, Dublin,
organised by the Society for the Protection of Unborn Children (SPUC).

2 August 1982

Opposite
Harvey Smith, leading rider of the winning Great Britain team at the Dublin Horse Show in the RDS,
Ballsbridge, Dublin, accepts the Aga Khan team trophy from Mrs Hely Hutchinson.

7 August 1982

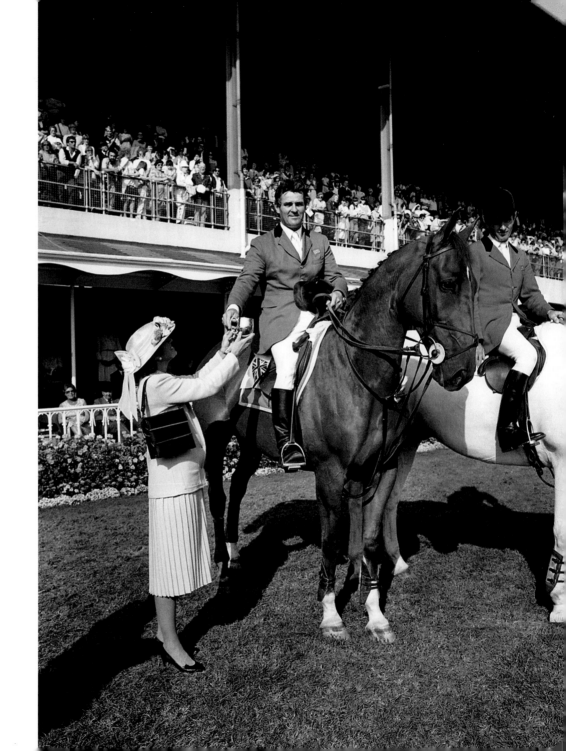

One of the final sections of the Kinsale–Dublin gas pipeline being installed. This section runs along the bank of the Grand Canal at Inchicore, Dublin.

16 August 1982

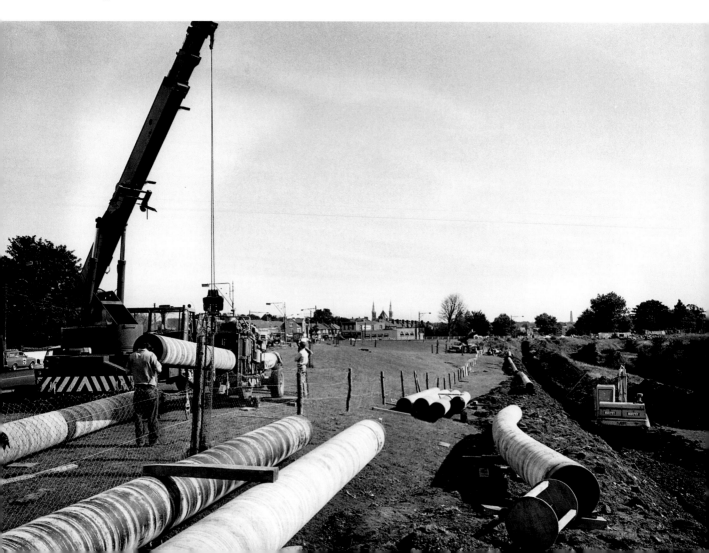

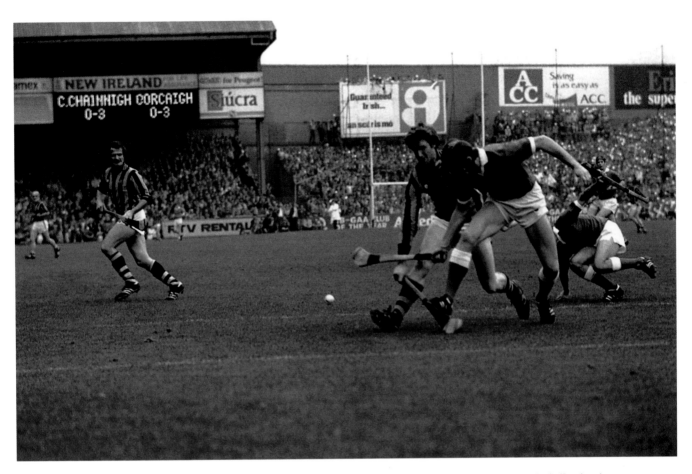

Martin O'Doherty of Cork beats Christy Heffernan of Kilkenny to the ball to break up a Kilkenny attack, at the All Ireland Hurling Final at Croke Park, Dublin. Kilkenny finally won the match, beating Cork 3–18 to 1–13.

5 September 1982

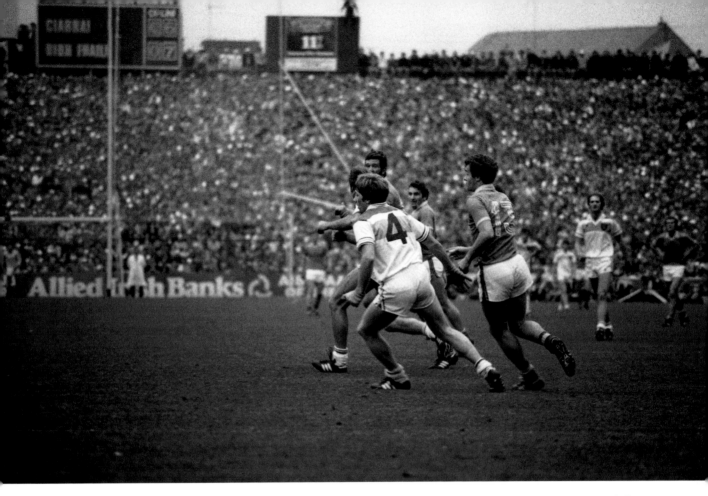

Lowry and Sheehy race to a breaking ball at the All Ireland Senior Football Final, between Offaly and Kerry. Offaly won the title by the narrowest of margins, 1-15 to 17 points, denying Kerry a record-breaking five in a row.

19 September 1982

Opposite
Bob Tisdall, who won a gold medal for the marathon at the 1932 Olympic Games, arrives in Dublin with his wife Peggy for an anniversary dinner in the Burlington Hotel.

24 September 1982

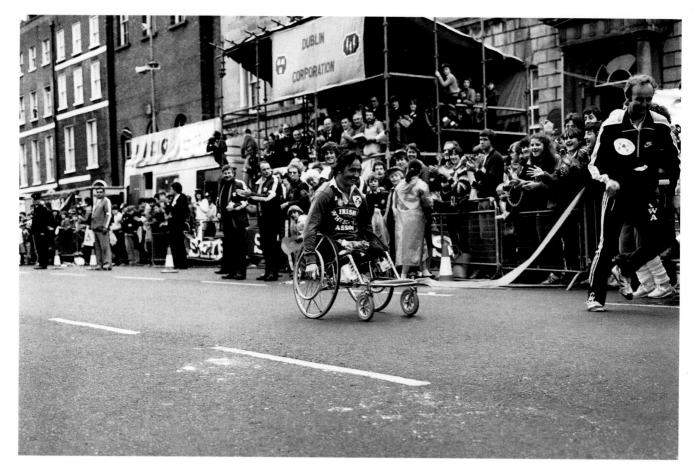

The finish of the Dublin City Marathon, at St Stephen's Green. Using just hand power, Michael O'Rourke approaches the finish line, cheered on by the crowd, to win the wheelchair event.

25 October 1982

Gerry Kiernan of Listowel, Kerry, looking remarkably fresh as he wins
the men's event at the Dublin City Marathon.

25 October 1982

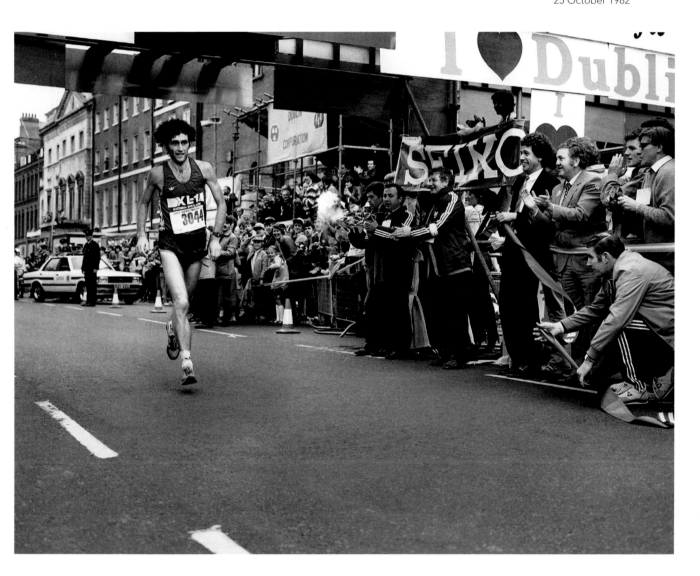

An attempt by Michael Moore of Lucan and Stephen Tisdall of Baldoyle, members of the Viking Sub-Aqua Club, to break the world underwater scuba endurance record. Started by Charles Haughey TD, at St Mary's Hospital, Baldoyle, County Dublin, the two aim to spend 100 hours underwater, and raise money for St Mary's Hospital for Physically Handicapped Children, Baldoyle.

26 December 1982

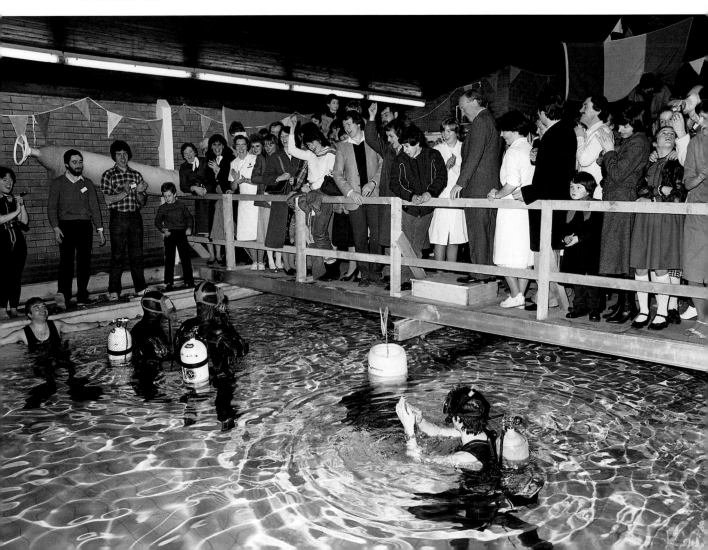

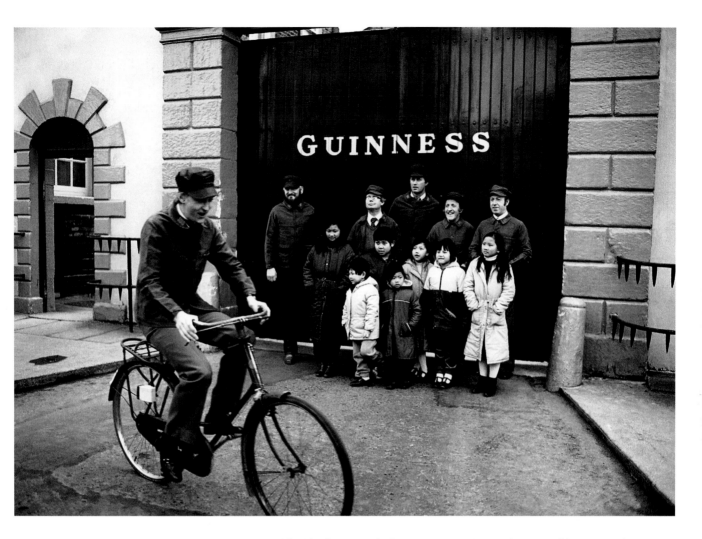

The Chieftains outside Guinness Brewery, St James's Gate, Dublin, meet with
some Chinese children on tour.

21 February 1983

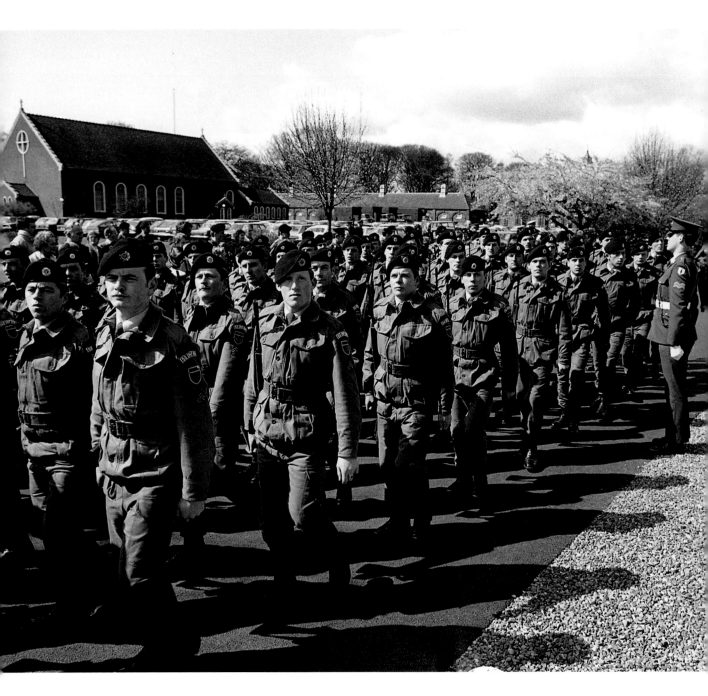

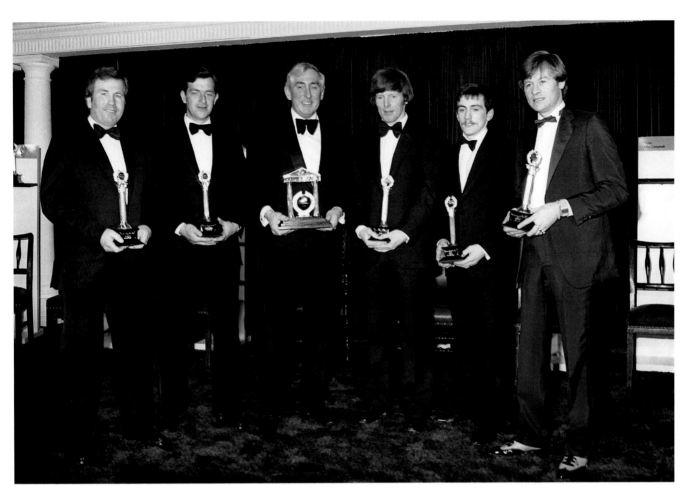

Texaco Sportstars of the Year awards. Pictured at the awards ceremony in the Burlington Hotel, Dublin, are (l–r): Noel Skehan, Hurling; Martin Furlong, Football; Ronnie Delaney, Athletics, Hall of Fame; Ollie Campbell, Rugby; Barry McGuigan, Boxing; and Alex Higgins, Snooker.

14 April 1983

Opposite
On the March. Troops from the 53rd Infantry Battalion, including some from the Southern Command, pass the reviewing stand at McKee Barracks, Cork.

12 April 1983

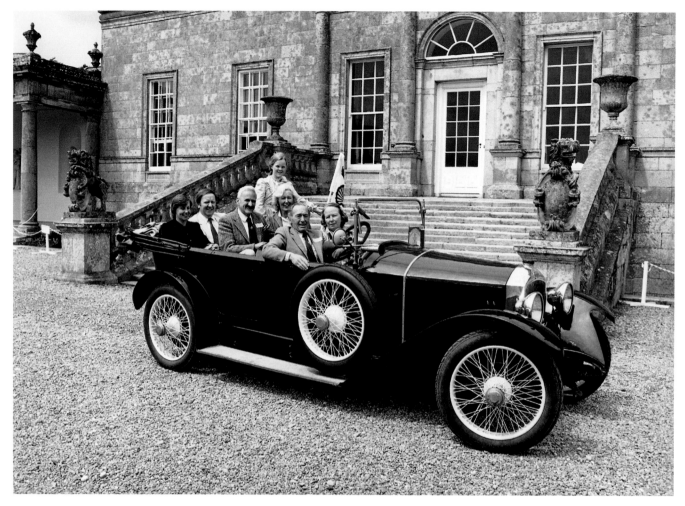

At the Irish Shell Ltd reception, Russborough House, Blessington, County
Wicklow, in Mr Maguire's Peugeot 1924, are (l–r): Mr and Mrs Rowe, Mr and
Mrs Bernan and Miss Grainne O'Carroll, and Mr and Mrs John and Pat Maguire,
President of the club.

30 June 1983

Bush plants tree: US Vice President George Bush, with his wife Barbara, planting a sapling in the grounds of the US Embassy Residence in Dublin.

5 July 1983

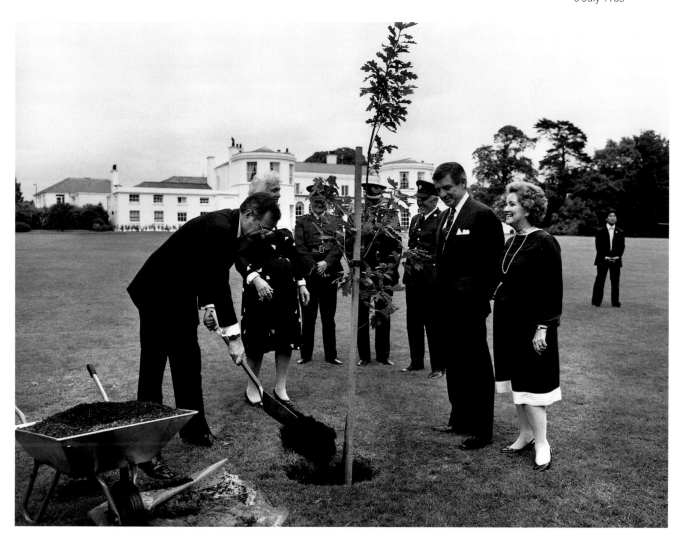

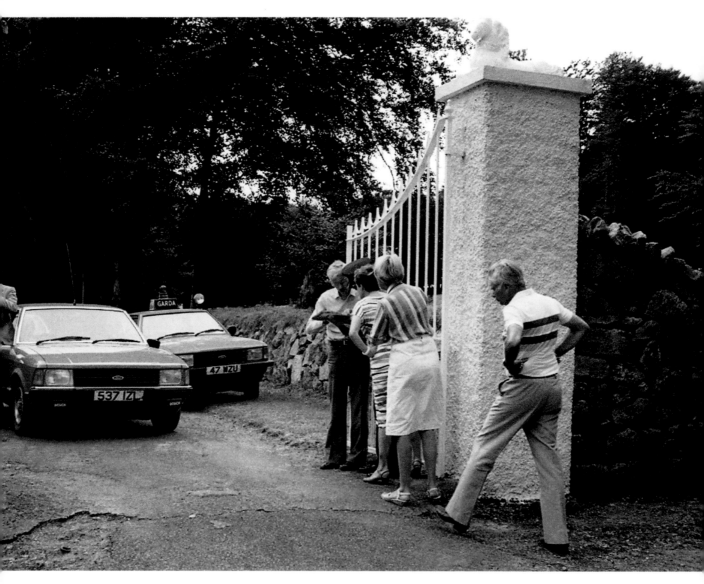

The aftermath of the shoot-out at the gates of Roundwood Park, Roundwood, County Wicklow, the home of supermarket executive Galen Weston. The Provisional IRA attempted a kidnapping at the house, but the police, having been tipped off, laid an ambush. In the ensuing firefight, four guerrillas were wounded.

7 August 1983

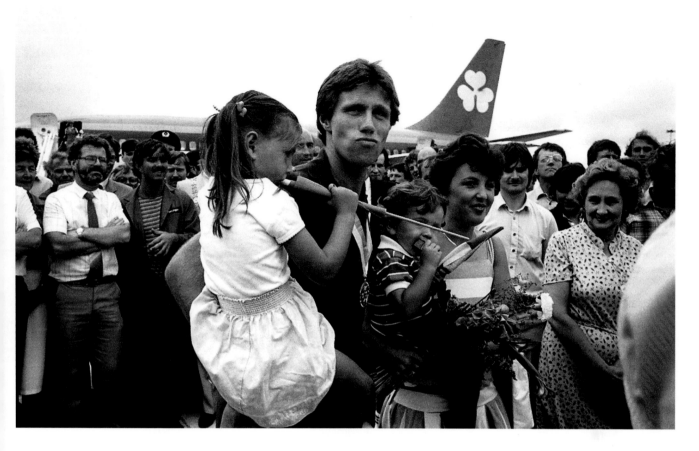

Gold medallist Eamonn Coughlan is surrounded by press and supporters on the tarmac of Dublin Airport on his return from the World Athletic Championships in Finland. His wife Yvonne and children Suzanne (four) and Eamonn Jr (two) are with him. His mother Kathleen looks on.

15 August 1983

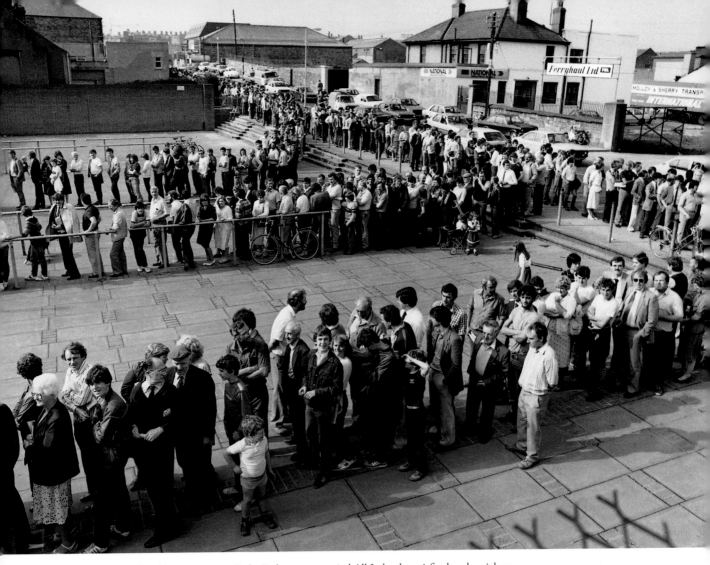

Thousands of Dubliners queue at Croke Park to capture vital All Ireland semi-final replay tickets.
The replay, between Dublin and Cork, was to be held in Cork. Dublin beat Cork in a very exciting
encounter, and went on to beat Galway 1-10 to 1-8 in the final at Croke Park.

28 August 1983

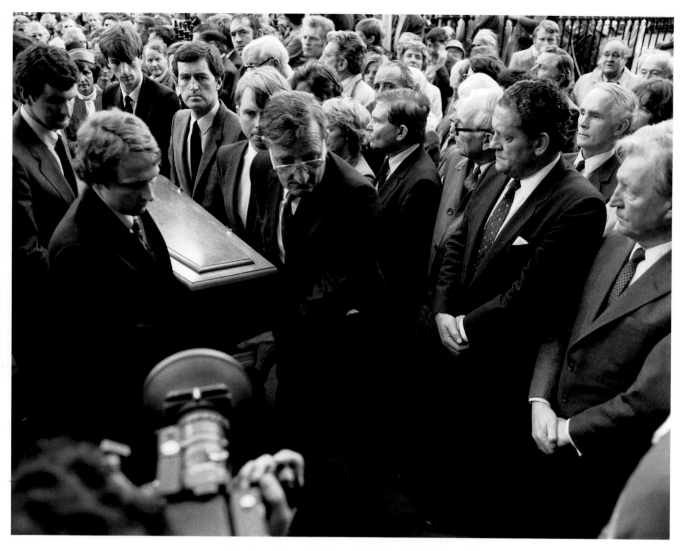

Family and friends of George Colley carry his remains into the Church of Three Patrons, Rathgar, Dublin. Many Fianna Fáil colleagues were present, including Charles Haughey TD and Brian Lenihan TD. In a long and distinguished political career, Colley had served as Minister for Education, Minister for Industry and Commerce, Minister for Finance, Minister for the Public Service, and Tánaiste.

19 September 1983

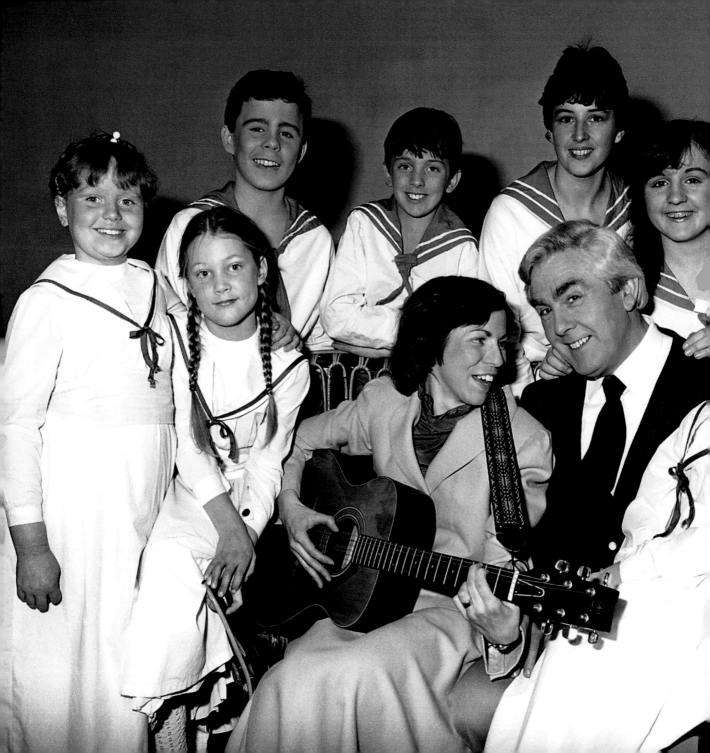

Dress rehearsal for the musical 'The Sound Of Music',
performed by the Pioneer Musical and Dramatic Society at the
SFX Hall in Dublin.

2 November 1983

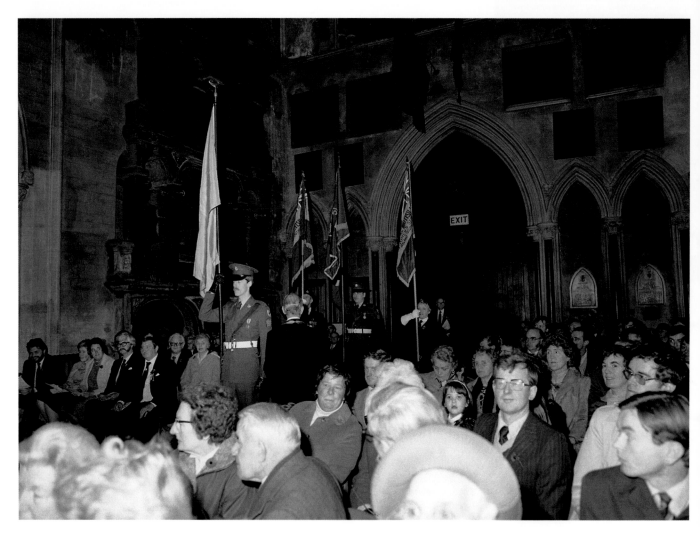

The colours are paraded to the altar during a Remembrance Day (Poppy Day) service held in St Patrick's Cathedral, Dublin, to commemorate the Irish who fell whilst on service with the British Army in the two World Wars.

13 November 1983

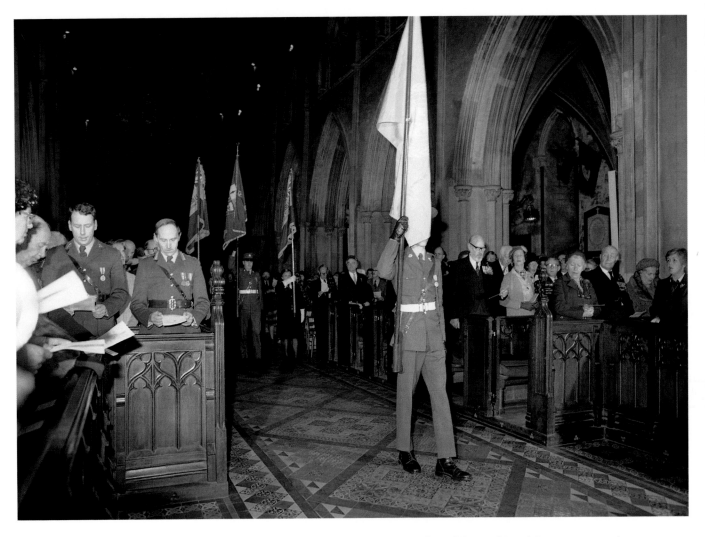

An Irish Army flag and the flags of the Royal British Legion are trooped to the altar during the Remembrance Day Service.

13 November 1983

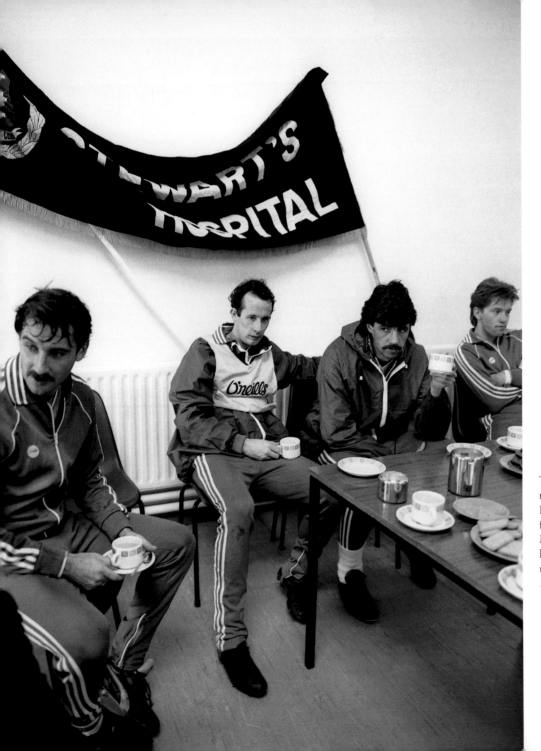

The Ireland soccer team in training at Stewarts Hospital, Palmerstown, Dublin, for the forthcoming match against Malta. Mark Lawrenson looks in thoughtful mode as the players have their tea.

14 November 1983

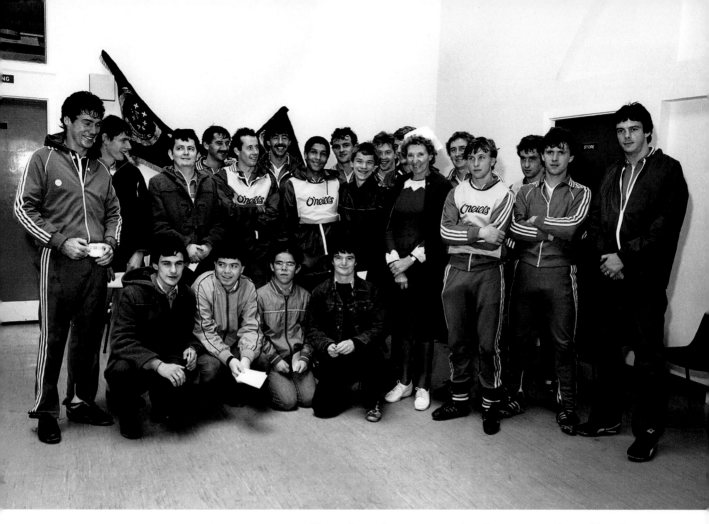

Players, fans and a nursing sister from Stewarts Hospital assemble at the Ireland soccer team training camp.

14 November 1983

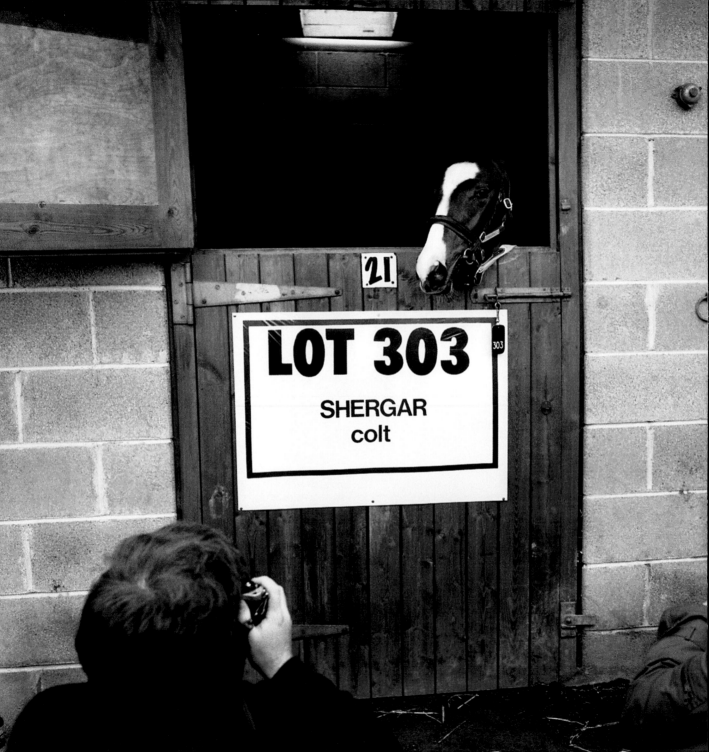

'Lot 303', an as yet unnamed foal sired by the
famous Shergar, poses for the cameras prior to
an auction to be held at Goffs Sales, Kildare. On
8 February 1983, Shergar was kidnapped from
the Ballymany Stud, Curragh, County Kildare,
allegedly by the IRA. Shergar had been syndicated
for £10 million by his owner, the Aga Khan, after
winning the Epsom Derby by a record ten lengths.
Despite a wide-ranging investigation, no trace of
the horse was ever found.

20 November 1983

Maureen Potter in a determined frame of mind as she leads the Irish theatre industry protest to Leinster House. With the imposition of a 23% VAT rate on theatre tickets, the theatre industry was feeling the strain. Also among the 'cast' are Brendan Grace, aka 'Bottler', in the background to the left, and the entertainer Tony Kenny, to the right.

7 December 1983

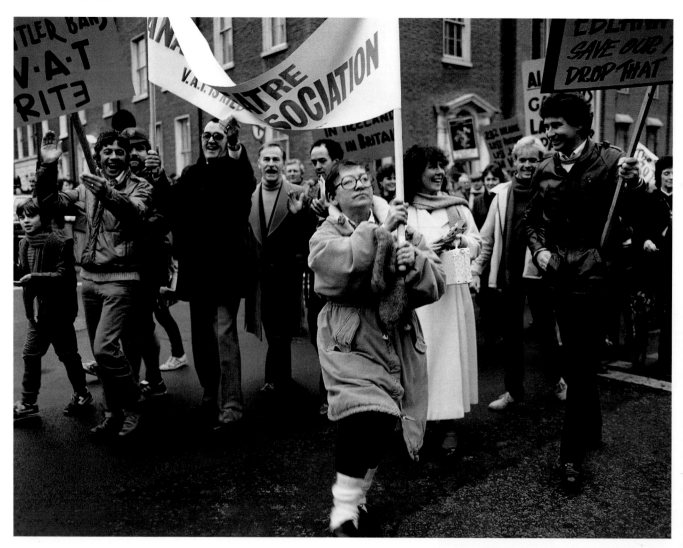

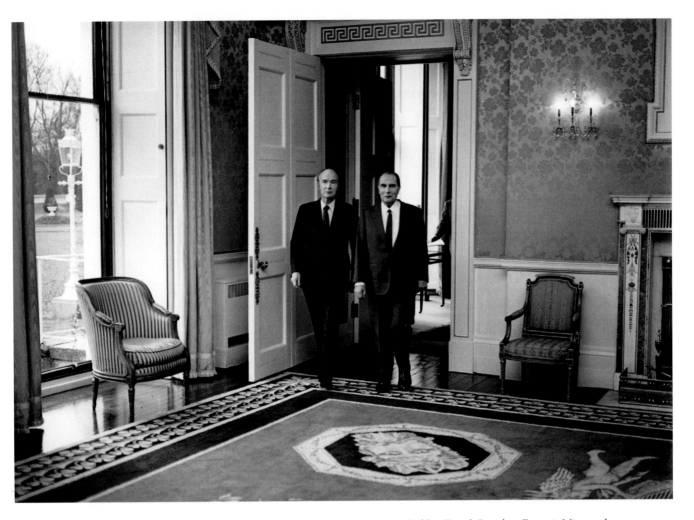

On a state visit to Dublin, French President Francois Mitterand paid a visit to Áras an Uachtaráin, where he was greeted by Irish President Patrick Hillery. Here President Hillery leads President Mitterand into the drawing room at the Áras.

21 February 1984

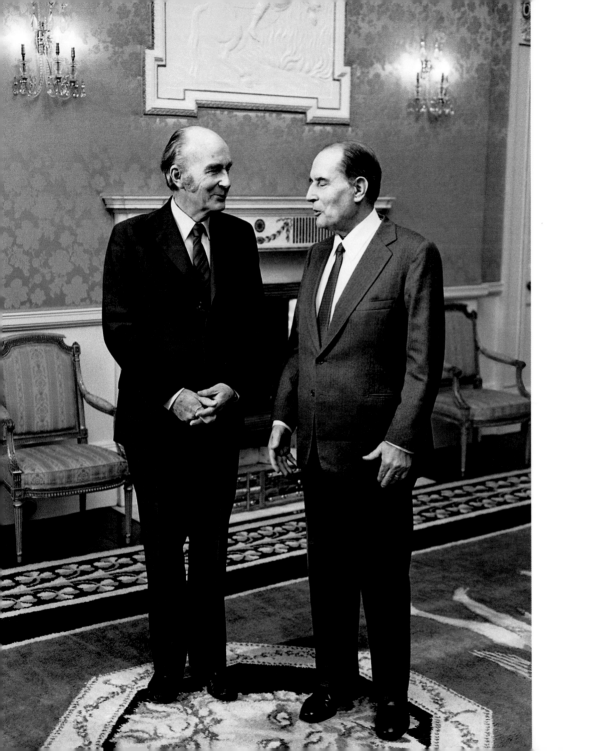

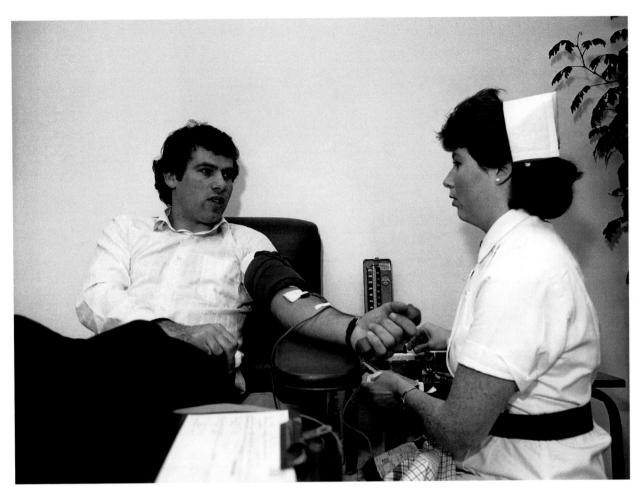

With a possible shortage of blood looming over the St Patrick's weekend, Irish rugby international Tony Ward leads an awareness campaign by donating blood at Pelican House, Mespil Road, Dublin. It clearly doesn't hurt a bit, as Tony chats with Nurse Barbara Maguire during the donation.

16 March 1984

Opposite
Presidents Hillery and Mitterand take their positions for the formal photo shoot at Áras an Uachtaráin, Phoenix Park, Dublin.

21 February 1984

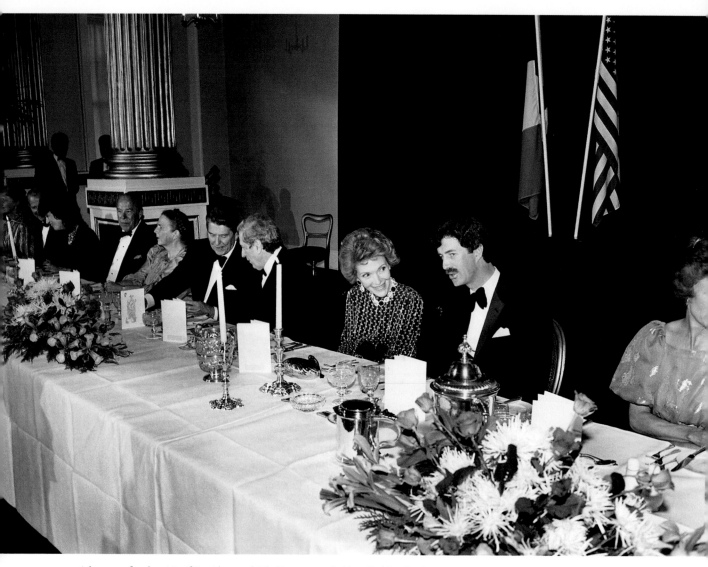

A banquet for the visit of President and Mrs Reagan was held in Dublin Castle, Dame Street, Dublin. Here Ronald and Nancy Reagan engage Taoiseach Garret FitzGerald and Tánaiste Dick Spring in conversation.

4 June 1984

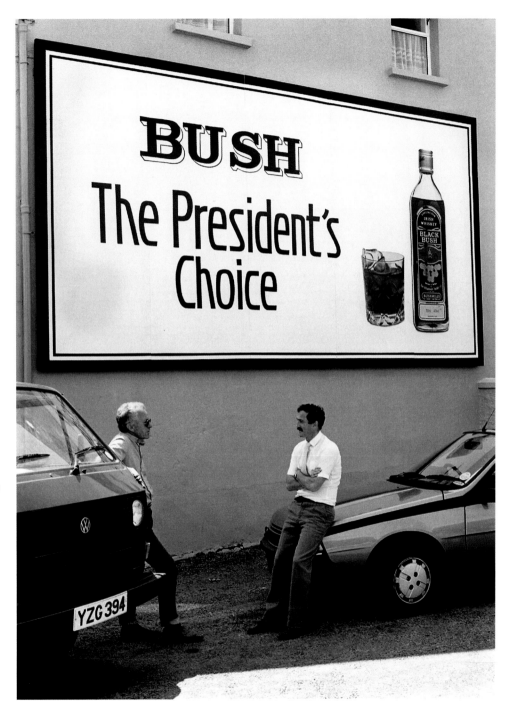

Following the visit of the Reagans, whiskey manufacturers quickly seize an opportunity to advertise their wares. Was this a foretelling of the future, the words Bush and President in the same sentence?

4 June 1984

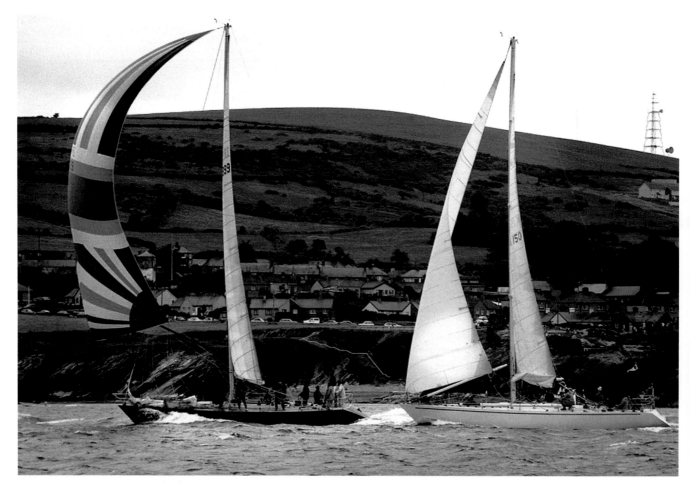

The Round Ireland Yacht Race is run every second
year, starting in 1980. The course, starting from
Wicklow Sailing Club, is simple: 'Leave Ireland and
all its islands excluding Rockall to starboard.' The
eventual winner was the yacht *Lightning*, in a time
of just under 102 hours.

23 June 1984

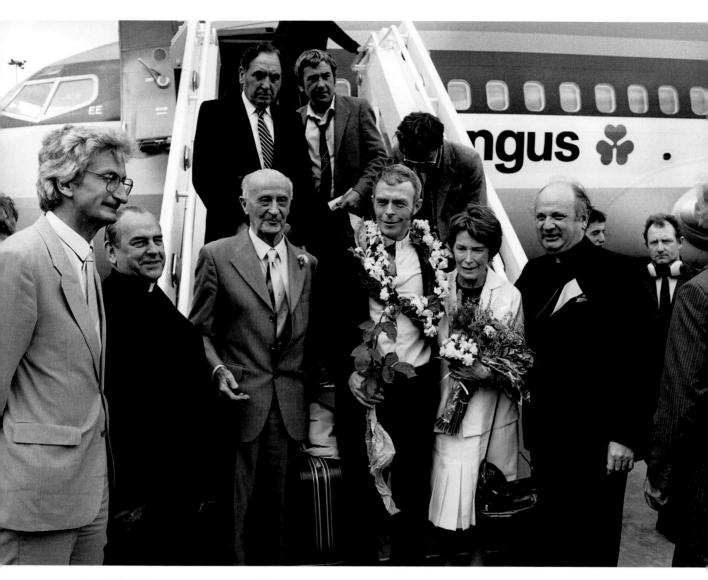

Father Niall O'Brien was arrested in the Phillipines, along with two other priests and six lay workers – the so-called 'Negros nine', accused of five murders. When Ronald Reagan visited Ireland, he was asked if he could help the missionary priest. A call from the US administration to Ferdinand Marcos resulted in a pardon. He was greeted by his parents at Dublin Airport. Also in the picture are Cardinal Tomás O Fiach, Jim O'Keefe TD, Minister of State at the Department of Foreign Affairs, and Bishop Eamon Casey.

14 July 1984

Marty Whelan (centre) with Spandau Ballet members Tony Hadley and Martin Kemp, conducting an interview for *Video File* for RTÉ.

21 August 1984

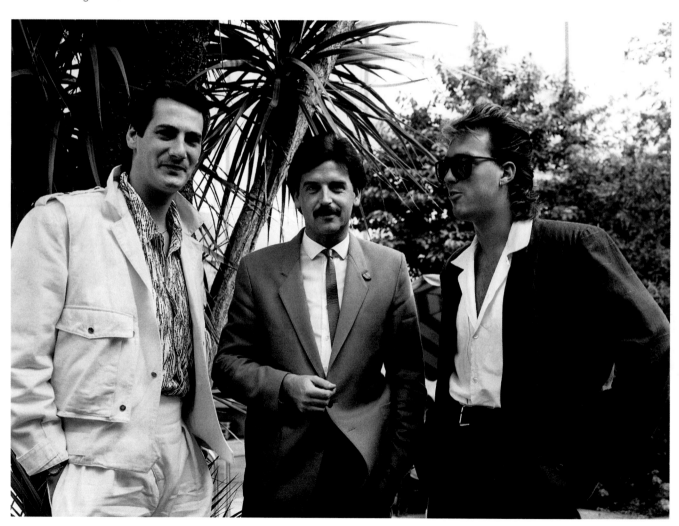

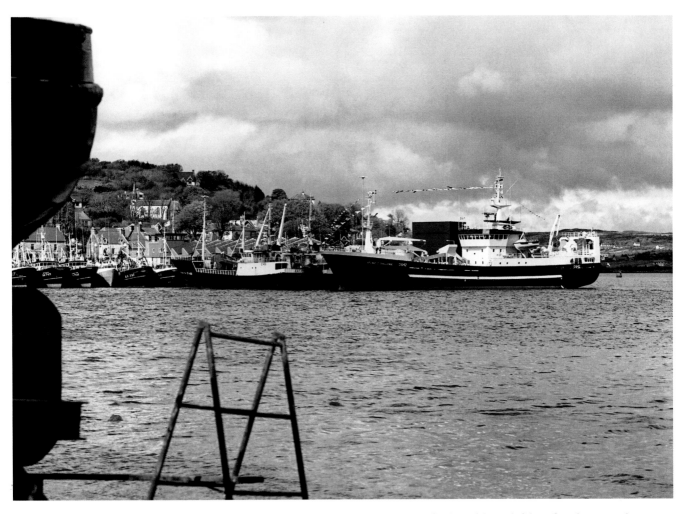

New IR£6 million supertrawler *Atlantic Challenge*, flagship of the Irish fishing fleet, lies moored at Killybegs. The trawler will fish for non-quota stocks, such as blue whiting and horse mackerel, to lessen dependence on mackerel as quotas are low for the Irish fleet.

17 May 1986

The National League camogie final was contested between Cork and Dublin at Lorcan O'Toole Park, Kimmage, Dublin. Here Muireann McCarthy, captain of the victorious Cork team, receives the cup from Mrs Mary Lynch, President of the Camogie Association.

18 May 1986

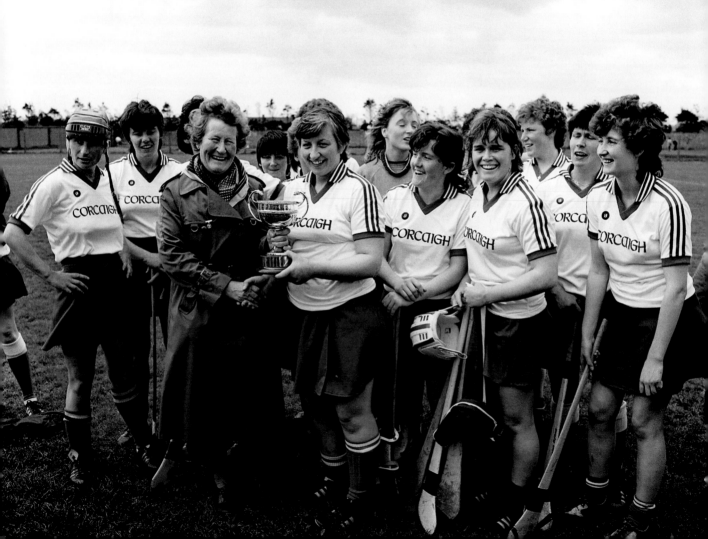

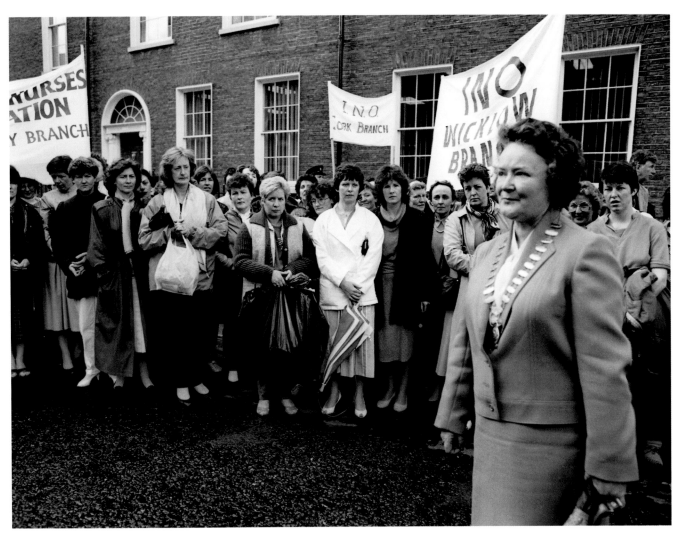

Bridget Butler, leader of the Irish Nurses Organisation, with nurses from all over the country as they march to Dáil Éireann to protest against proposed health cuts.

28 May 1986

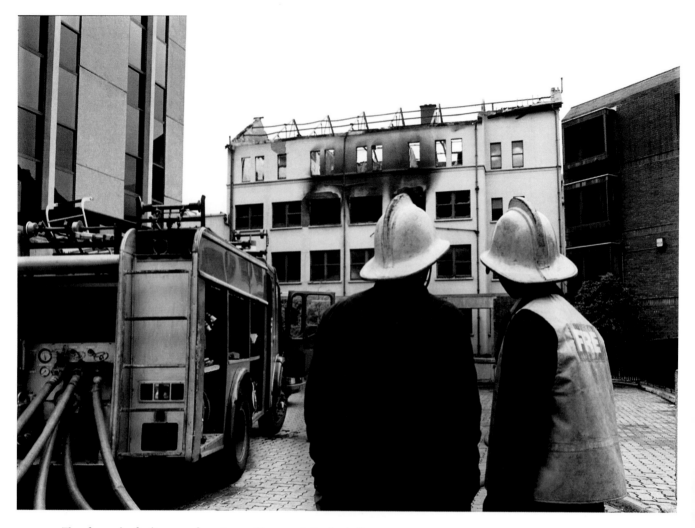

The aftermath of a disastrous fire at Loreto Convent, St Stephen's Green, Dublin, which claimed the lives of six elderly nuns. The nuns, retired teachers at the school attached to the convent, were named as sisters Edith, Eucharia, Seraphia, Margaret, Rosario and Gonzaga. Fifteen other nuns managed to escape the inferno, which broke out on the top floor of the 150-year-old convent, in the nuns' dormitories.

2 June 1986

Artist Pauline Bewick discusses her work 'Holly and Ell Coffey Doll' with John Taylor, Director of Taylor Galleries, at her exhibition '2 to 50 Years' at the Guinness Hops Store, Dublin. The exhibition is a collection of her work from age two to the present, ranging from simple pencil sketches to more complex paintings and lino cuts.

3 June 1986

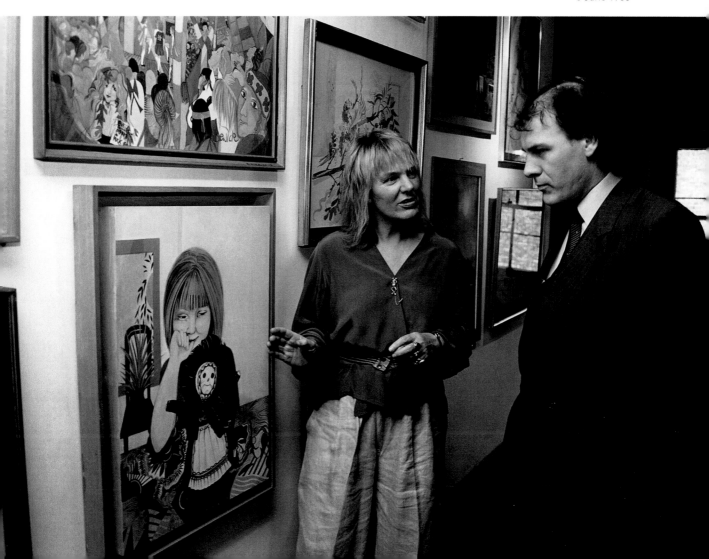

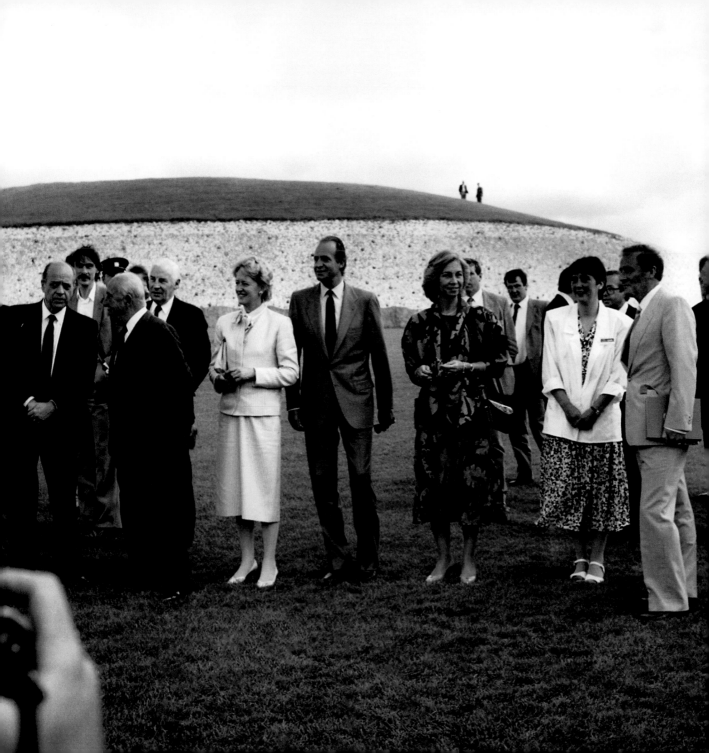

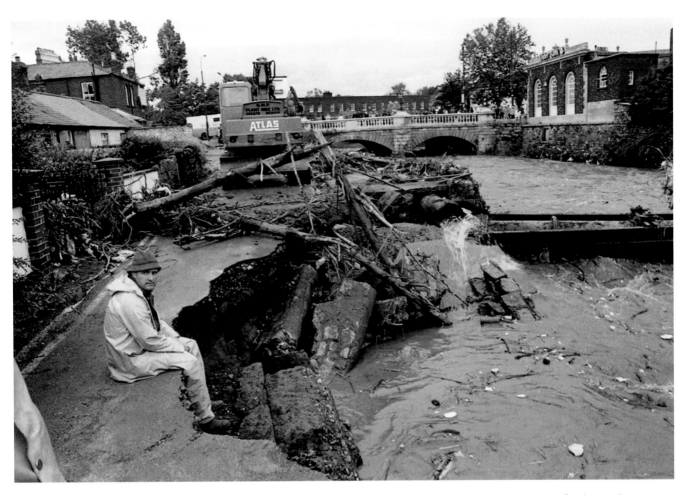

Hurricane Charlie caused tumultuous overnight rainfall, resulting in severe flooding in the Donnybrook and Ballsbridge areas of Dublin. In just twelve hours, eight inches of rain fell, causing the Dodder, long regarded as a 'flashy' river, to burst its banks and flood 300 homes. Council workers and fire brigades did their best to alleviate hardship, removing debris and pumping out some of the homes affected.

28 August 1986

Opposite:
King Juan Carlos and Queen Sofia of Spain visit the burial mound of Newgrange
as part of their state visit to Ireland.

30 June 1986

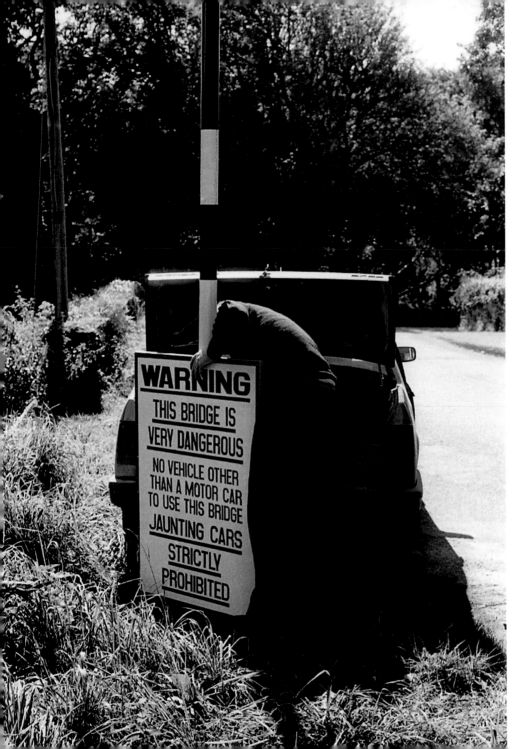

A sign is erected in Killarney, advising on the safety or otherwise of a bridge in the area.

2 September 1986

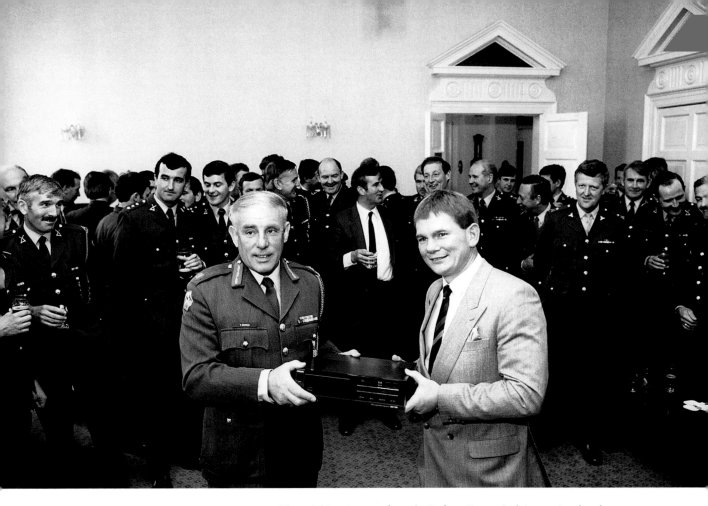

To mark his retirement from the Defence Forces, Irish international rugby legend Ciaran Fitzgerald is presented with a hi-fi system by Brigadier General Vincent Savino on behalf of his friends and colleagues.

5 September 1986

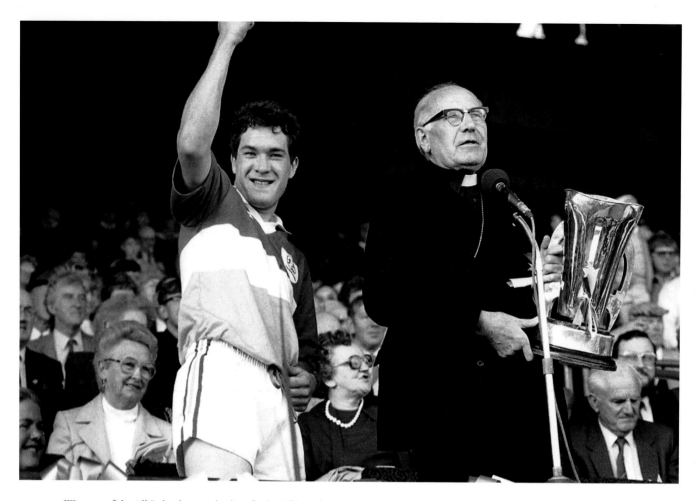

Winners of the All Ireland minor hurling final, Offaly defeated Cork with a score of 3-12 to 3-9. Here the victorious Offaly captain, Michael Hogan, is about to receive the Irish Press Cup from Dr T Morris, Archbishop of Cashel.

7 September 1986

In the senior hurling final, Cork emerged victorious over a much-fancied Galway team, with a score of 4-13 to Galway's 2-15. The team are introduced to President Dr Patrick Hillery by Cork captain Liam Cashman.

7 September 1986

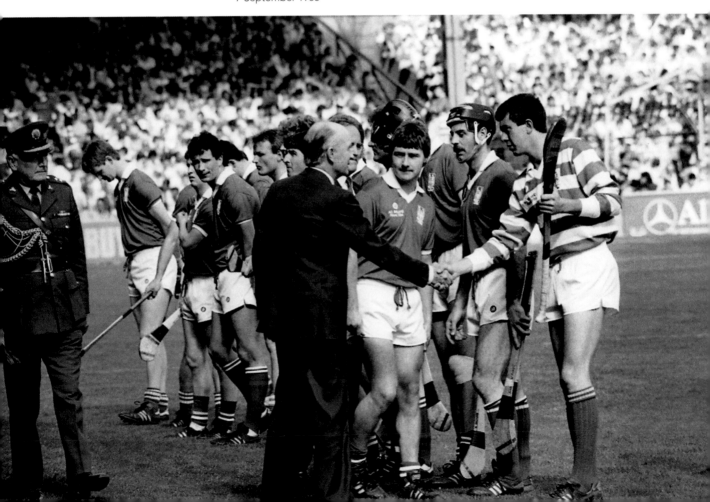

Prince Albert of Monaco is greeted by reporters at Iveagh House, Dublin, along with George Bermingham TD, Minister of State at the Department of Foreign Affairs, as part of his visit to Ireland.

19 September 1986

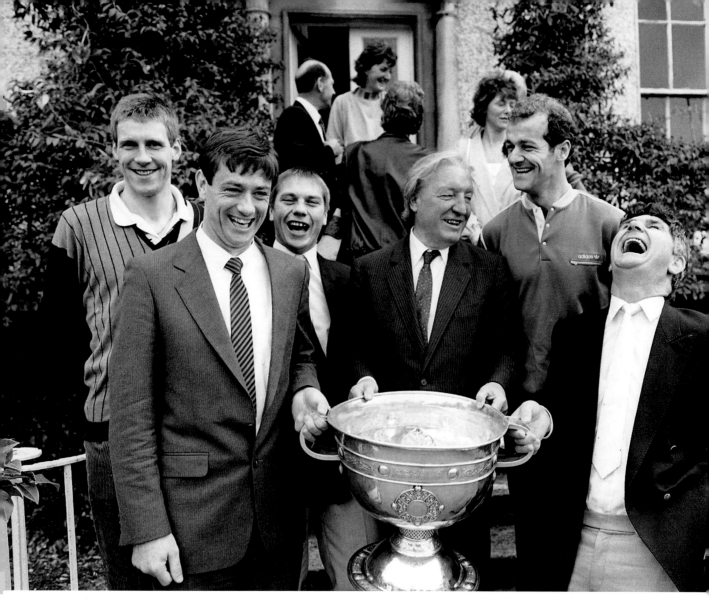

Members of Kerry's All-Ireland-winning team pay a courtesy call to Abbeyville, the home of Charles Haughey TD, along with the Sam Maguire cup, won at Croke Park the previous day. (l–r:) Tom Spillane, Tommy Doyle, Paudie Ó Sé, Charles Haughey, Jack O'Shea and Mick O'Dwyer.

22 September 1986

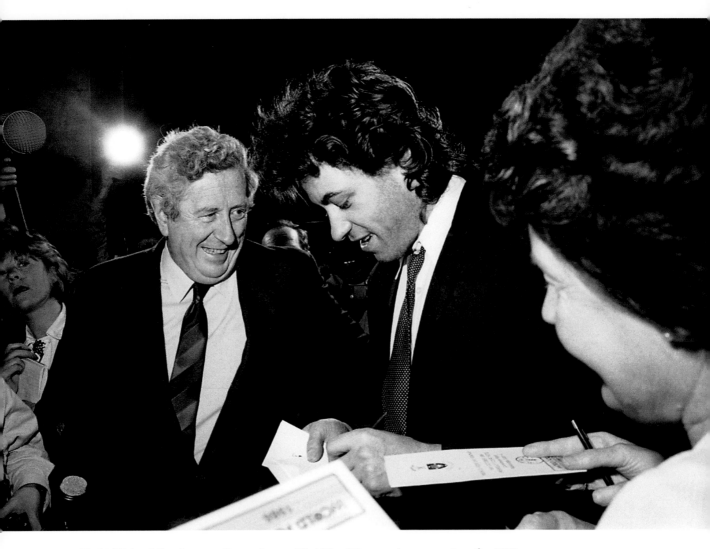

The highlight of Gorta's twenty-first anniversary World Food Day was the presentation of an FAO (UN Food and Agriculture Organisation) medal to Bob Geldof. The medal was presented by An Taoiseach Dr Garret FitzGerald in recognition of Bob's contribution towards famine relief in the third world. In the midst of the media scrum, and deep in conversation with the Taoiseach, Bob still has time to sign autographs for fans.

16 October 1986

On 23 October, schoolboy Philip Cairns was returning to school after lunch, but never arrived. A week later, his schoolbag was found in an alleyway close to his home in Rathfarnham. It is suspected that his abductor planted the bag in order to dispose of evidence and to confuse the Garda investigation. Up to today, his disappearance remains a mystery.

30 October 1986

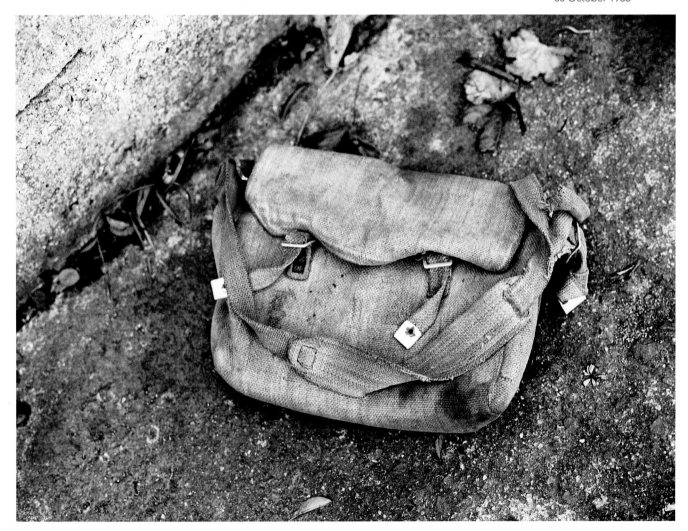

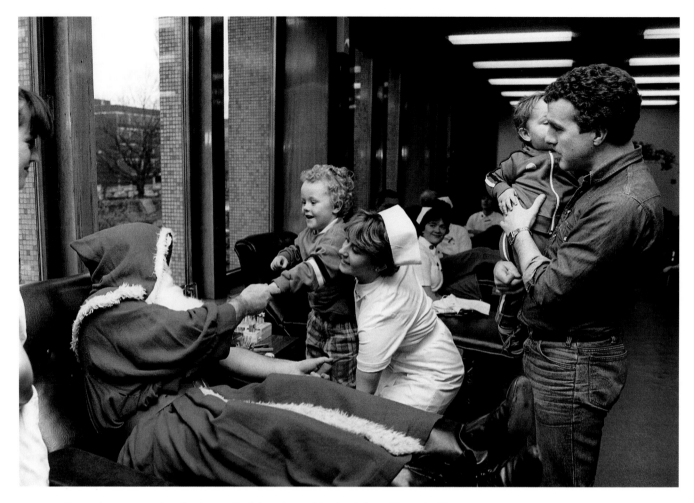

Santa takes time out from his hectic schedule to donate blood at Pelican House, Dublin. Christmas is a very busy time at Ireland's hospitals, and a steady supply of blood is vital to saving lives. Even during his donation, Santa has the time to spread Christmas joy to two small children.

15 December 1986

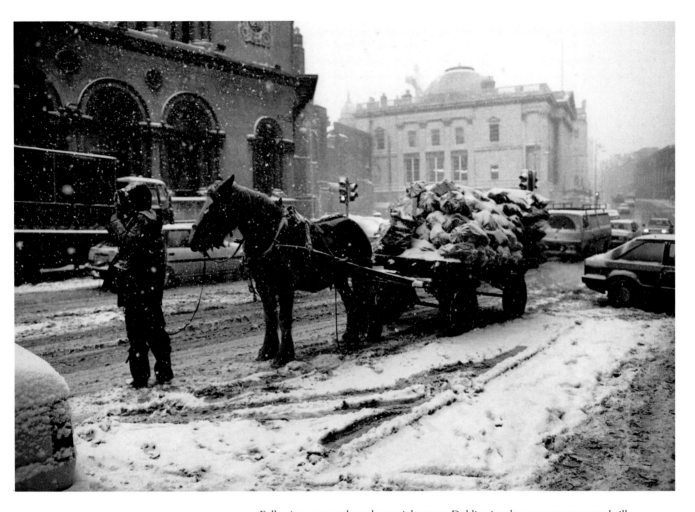

Following unprecedented overnight snow, Dublin city almost comes to a standstill.
Even a horse and cart carrying winter fuel is finding progress slow through the
snow-covered streets.

14 January 1987

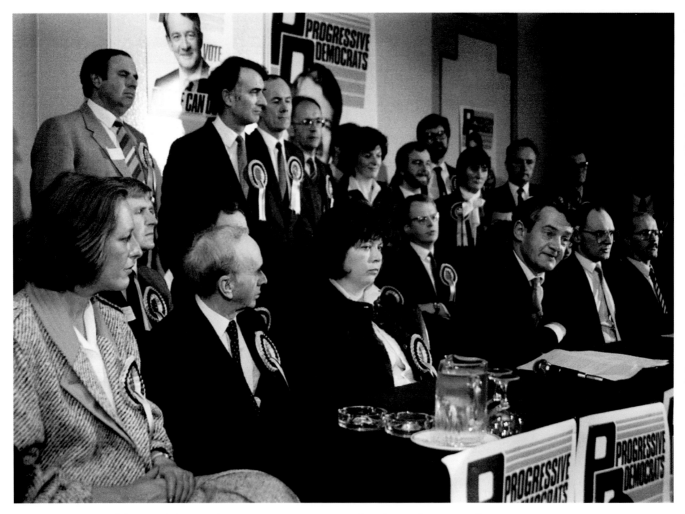

In advance of the general election, the Progressive Democrats party launches its election manifesto.
Party leader Des O'Malley is surrounded by election candidates at the press conference in the
Burlington Hotel, Dublin.

21 January 1987

Opposite
Workers' Party leader Tomás MacGiolla lays a wreath at the memorial for trade union leader James Larkin in
O'Connell Street, Dublin, to commemorate the fortieth anniversary of Larkin's death. Also in the picture are
Prionsias De Rossa and councillors Eric Byrne, Eamon Gilmore, Mike Jennings and Pat Rabbitte.

7 February 1987

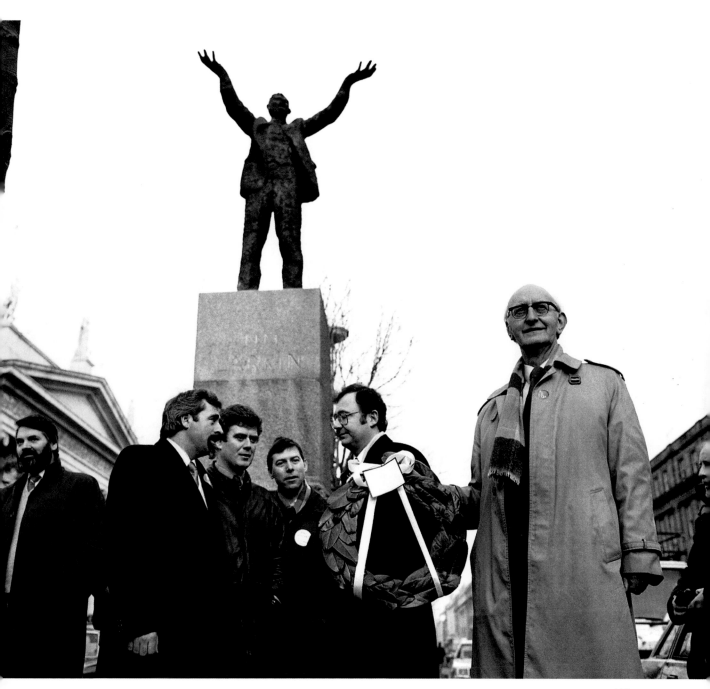

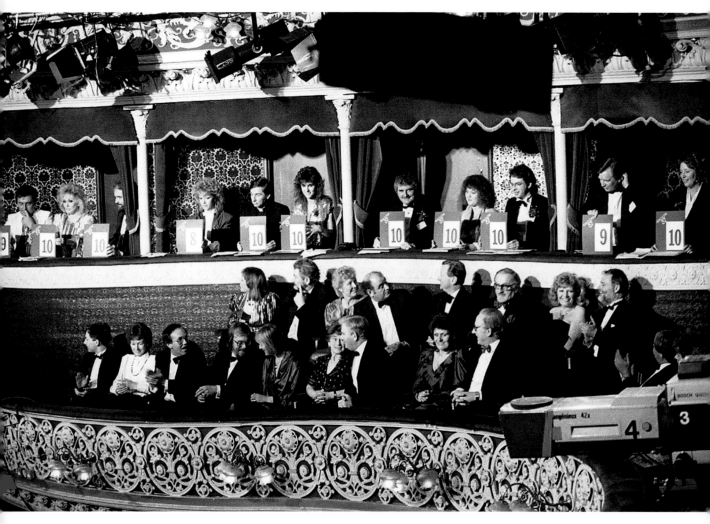

The adjudicating panel cast their votes at the Eurosong final in the Gaiety Theatre, Dublin. Johnny Logan, singing his own composition 'Hold Me Now', beat off strong competition for the right to represent Ireland in the Eurovision Song Contest in Brussels. Logan previously won the competition with 'What's Another Year', a collaboration with Shay Healy.

8 March 1987

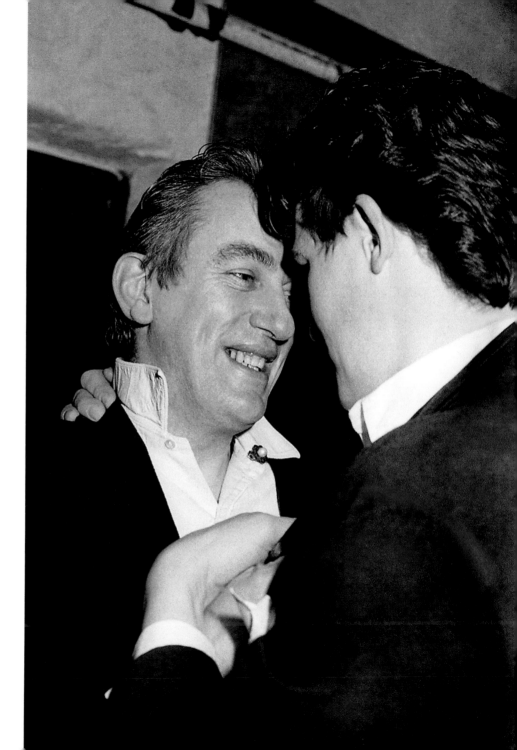

Shay Healy, who was a
Eurovision winner with
Johnny Logan in 1980, is
on hand to congratulate
Johnny on his win.

8 March 1987

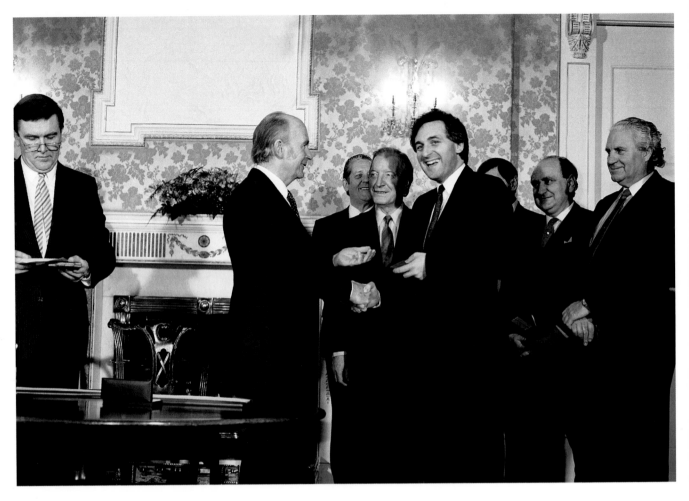

After their win in the recent general election, the new Fianna
Fáil government, under the leadership of Charles Haughey, is
sworn in and given their seals of office at a ceremony in Áras an
Uachtaráin. President Hillery presents the seal of office to Bertie
Ahern at the ceremony in the Árás.

10 March 1987

Opposite
Members of the new government, Mary O'Rourke and her
brother Brian Lenihan proudly display their seals of office.

10 March 1987

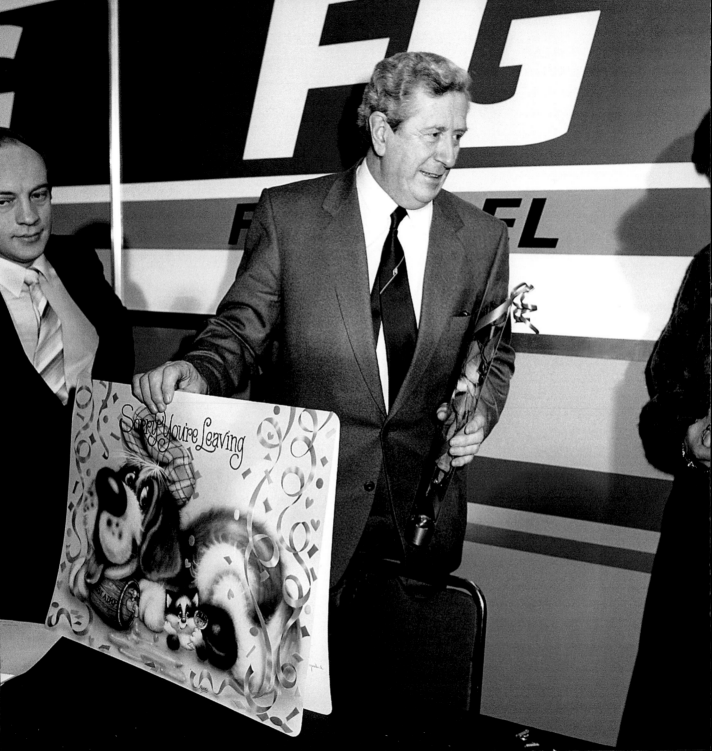

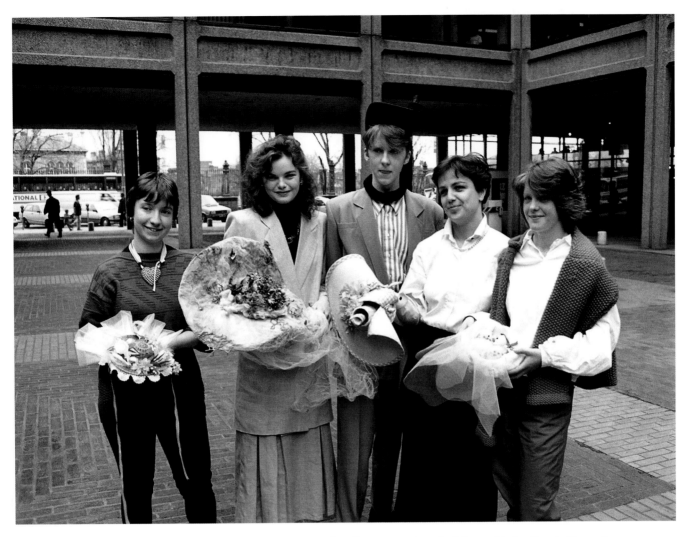

As part of an Easter promotion, the Kilkenny Design Shop in Nassau Street, Dublin, sponsored an Easter bonnet design competition.

16 April 1987

Opposite
'Sorry You're Leaving': After losing the recent general election, Dr Garret FitzGerald announces his resignation as leader of the Fine Gael party at a press conference at Jury's Hotel, Dublin.

11 March 1987

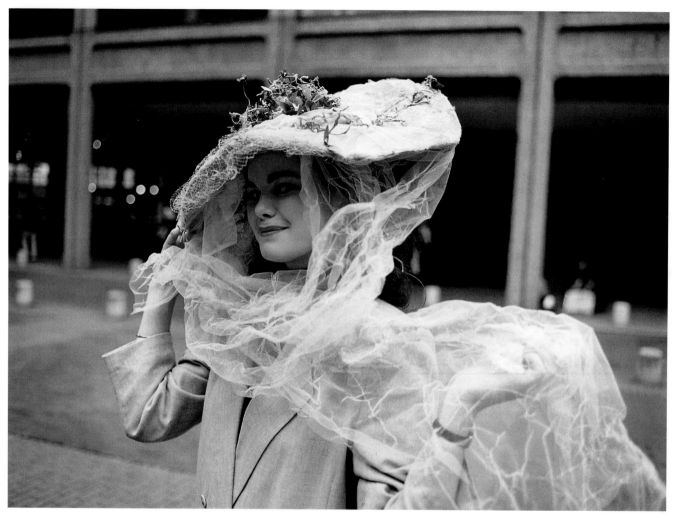

One of the fantastic designs submitted to the Kilkenny
Design Easter bonnet design competition.

16 April 1987

Opposite
The Easter Racing Festival at Fairyhouse, County Meath, includes the running of the Irish
Grand National and the Jameson Gold Cup. Here the stable girl, owner and winning jockey
pose for pictures with the winning horse, Brittany Boy, in the winner's enclosure.

20 April 1987

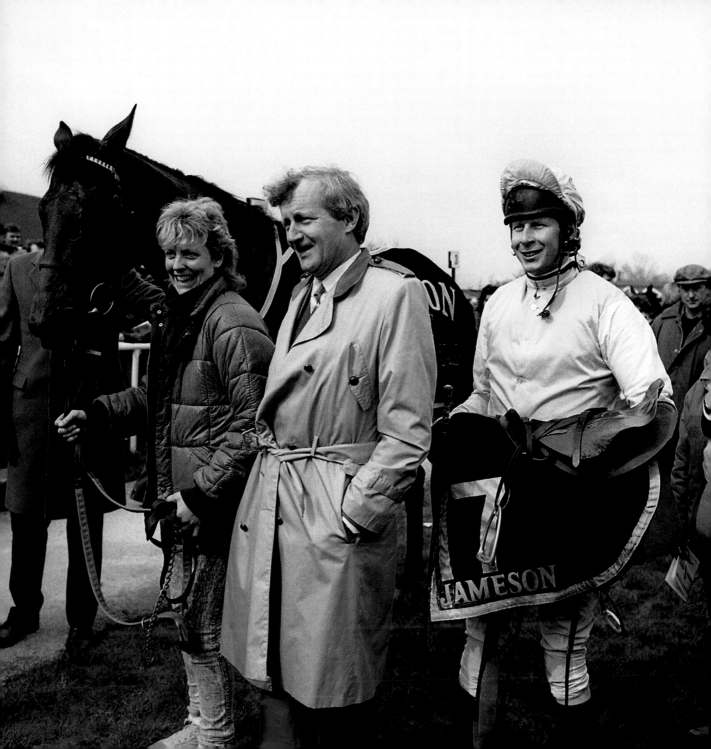

Contestants in the International Sheep Shearing and Fleece Rolling
Championship keep up a steady rhythm as they roll and tie fleeces under
the watchful eyes of the judges at the RDS in Dublin.

7 May 1987

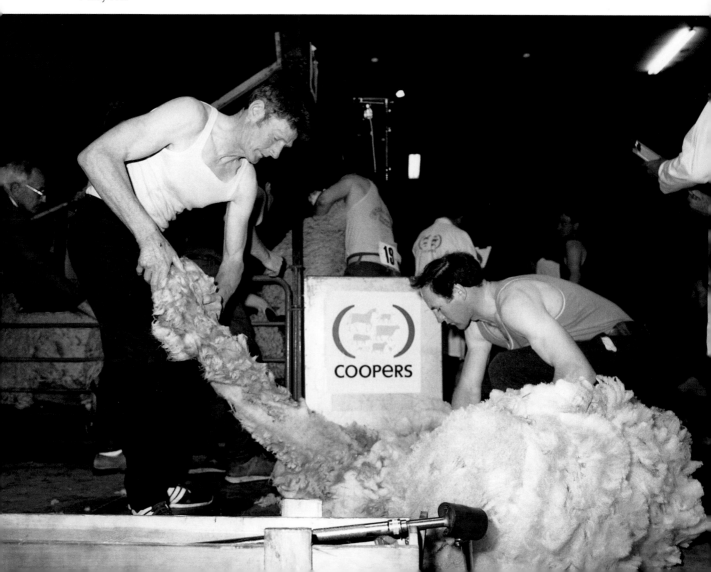

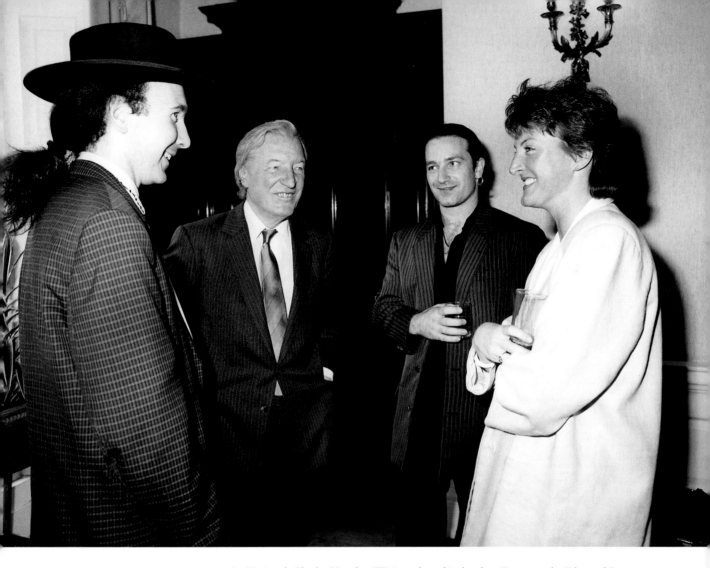

An Taoiseach Charles Haughey TD introduces his daughter Eimear to the Edge and Bono at a reception to welcome U2 home after a highly successful tour of America. The event was held in Iveagh House, Dublin, formerly a home of the Guinness family and now home to the Department of Foreign Affairs.

18 May 1987

137

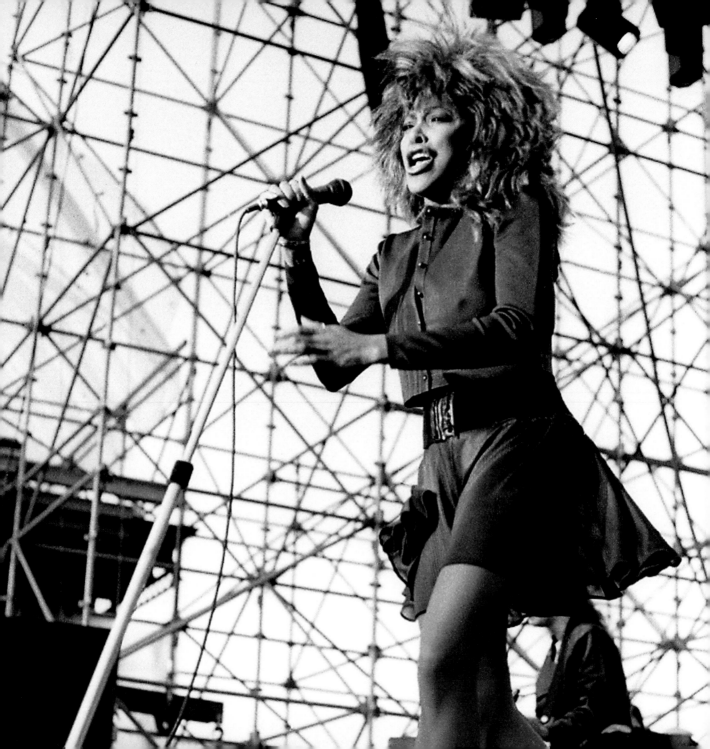

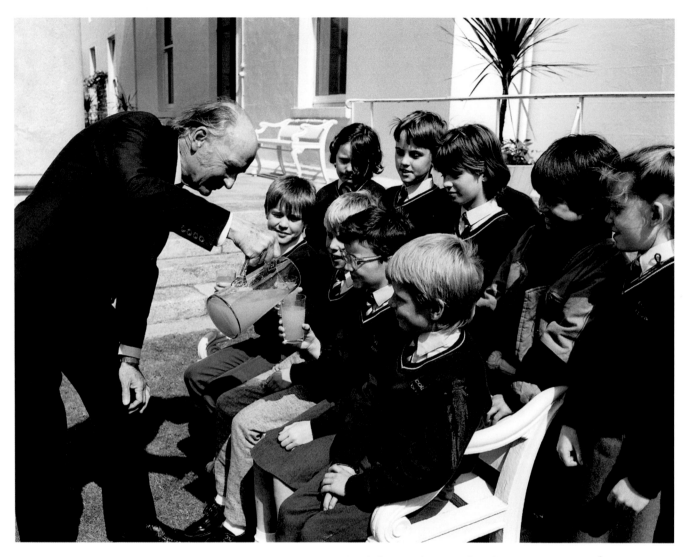

Pupils from Scoil Barra, Ballincollig, Cork, on a tour of Áras an
Uachtaráin, were lucky enough to have the highlights of the Áras
pointed out by the president himself, Dr Hillery.

15 June 1987

Opposite
A stop on her world tour, Tina Turner
thrills a sell-out crowd at the RDS,
Dublin, with renditions of her classic hits.

30 May 1987

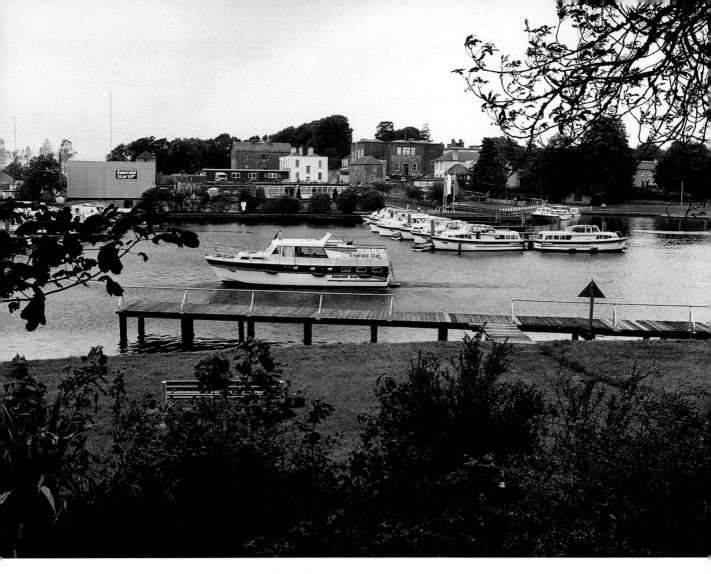

An Emerald Star cruiser on the Shannon, in front of the new customer service facility at Carrick-on-Shannon opened by Minister for Transport and Tourism John Wilson TD. Following viewing of the facility and the planting of a commemorative tree, the Minister departed on a cruise of the Shannon.

8 June 1987

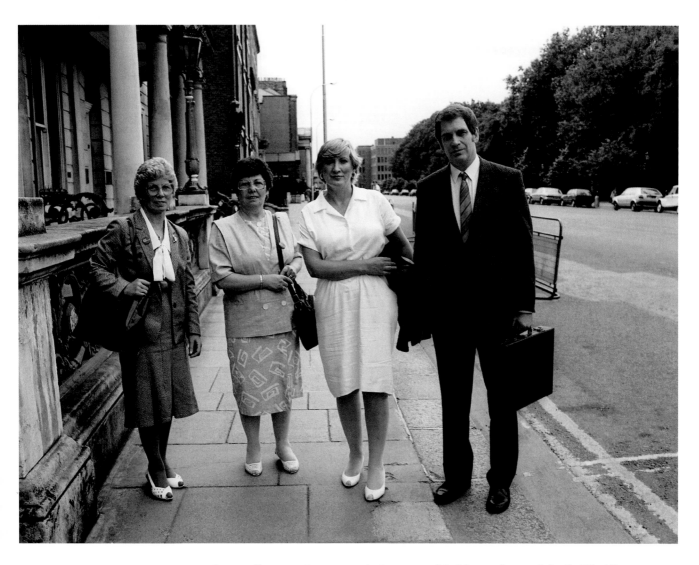

As part of her campaign to prove the innocence of the Maguire Seven and the Guildford Four, Annie Maguire takes her case to Tánaiste Brian Lenihan, at Iveagh House in Dublin. The Four and Seven were wrongly convicted of pub bombings carried out by the IRA in England. (l–r:) Annie's sister Mary McCaffery, Annie Maguire, Therese Smalley and Errol Smalley, Chairman of the Guildford Four and Maguire Family Relatives Support Group.

7 July 1987

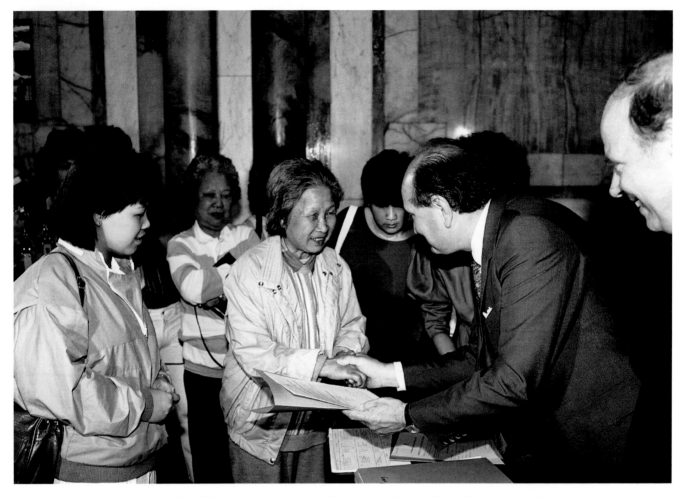

Justice Minister Gerard Collins TD presents a large group of Vietnamese refugees with certificates of naturalisation at the Department of Foreign Affairs in Iveagh House. The group of 156 adults, dispossessed due to the Vietnam war, arrived in Ireland from Vietnam and some refugee camps in Hong Kong and Malaysia.

8 July 1987

Opposite

In 1985, Shaun Aisbitt from Ballybough in Dublin was declared to be the tallest man in Ireland. His shoes are reckoned to be size twenty-two. The shoes are on display in the Dublin Civic Museum in South William Street, Dublin, and one is shown here in comparison to a size eleven shoe.

22 July 1987

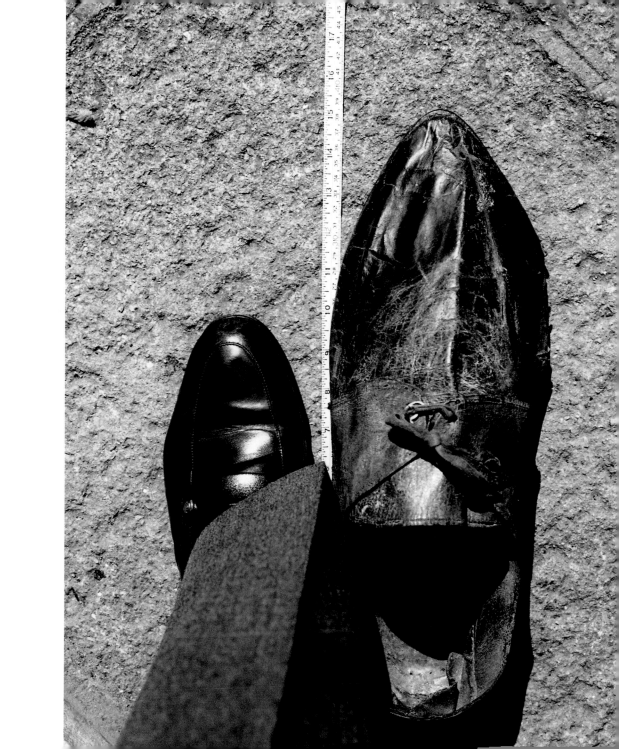

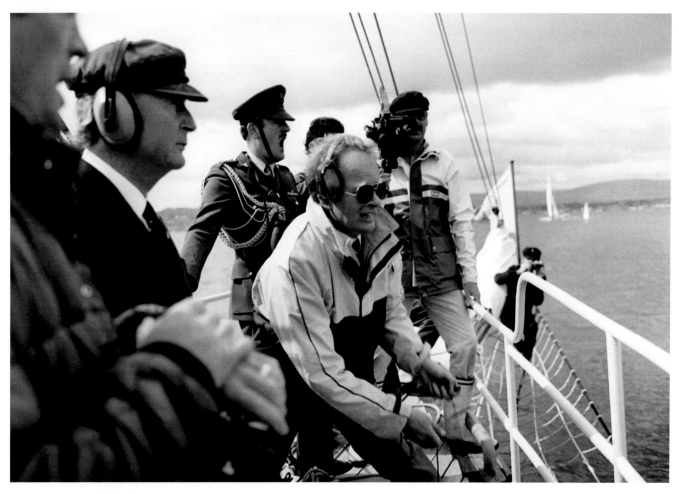

President Patrick Hillery watches the yachts depart after firing the starting cannon to start the Round Europe Yacht Race. Beginning at Dún Laoghaire, the first leg of the race will take the boats to Lorient, France.

25 July 1987

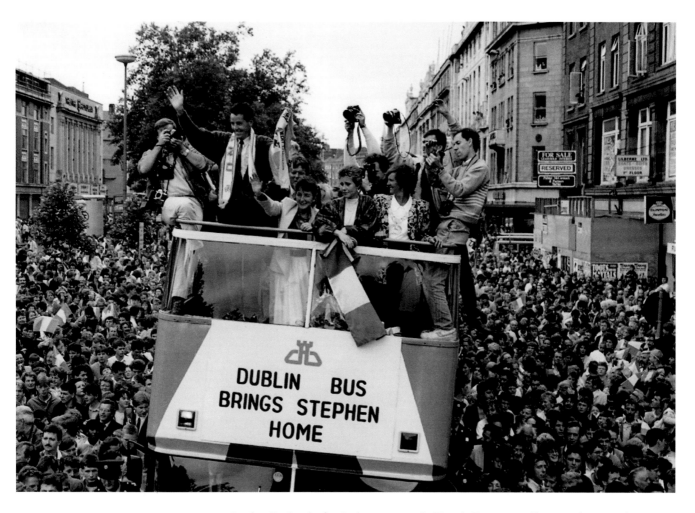

Stephen Roche, the first Irishman to win the Tour de France, proudly waving his winner's yellow jersey as he is paraded through the streets of Dublin. The people of Ireland thronged the streets to congratulate Stephen on his momentous achievement. Lydia Roche and Lord Mayor of Dublin Carmencita Hederman are also in the photograph.

27 July 1987

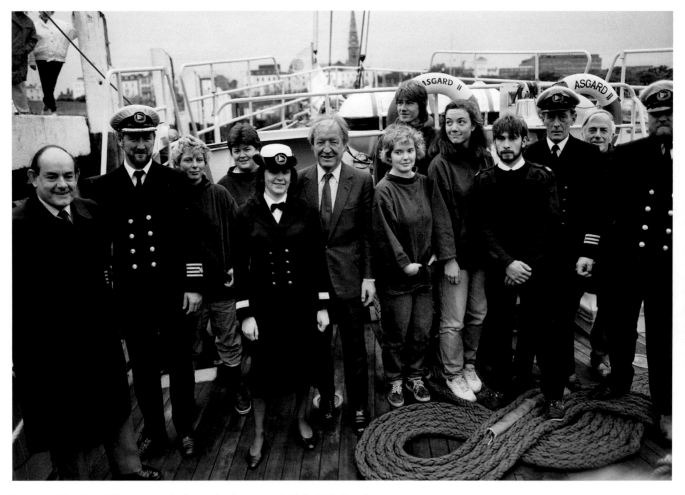

The *Asgard II*, a purpose-built training brigantine built by Jack Tyrrell in Wicklow, prepares to depart from the National Yacht Club in Dún Laoghaire en route to Australia. On hand to bid her 'bon voyage' were An Taoiseach Charles Haughey TD and Frank Milne, the Australian Ambassador to Ireland (far left).

15 October 1987

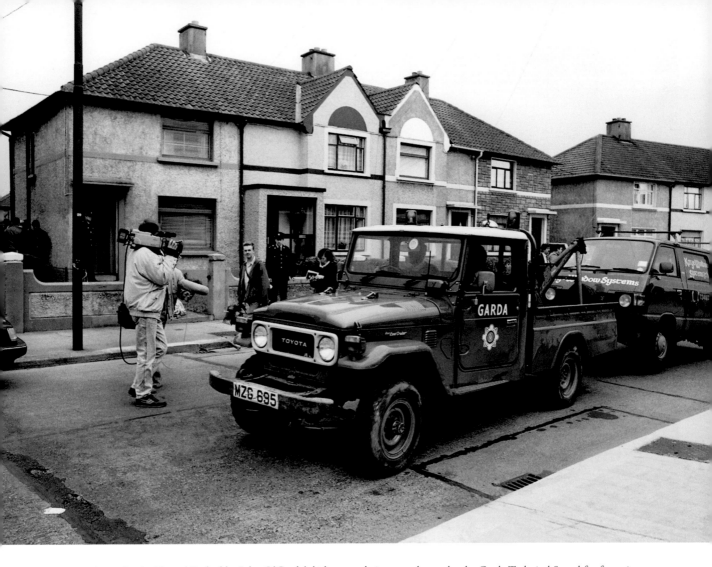

A van that had been hijacked by John O'Grady's kidnappers being towed away by the Garda Technical Squad for forensic examination. Twenty-one days after being kidnapped from his home in Cabinteely, County Dublin, John O'Grady was rescued by Gardaí from a house in Cabra West, Dublin. During his ordeal Mr O'Grady was mutilated by the kidnappers, led by Dessie O'Hare, to apply pressure on his family to pay a ransom. In an ensuing gun battle with the kidnappers, a detective garda was shot and seriously wounded.

5 November 1987

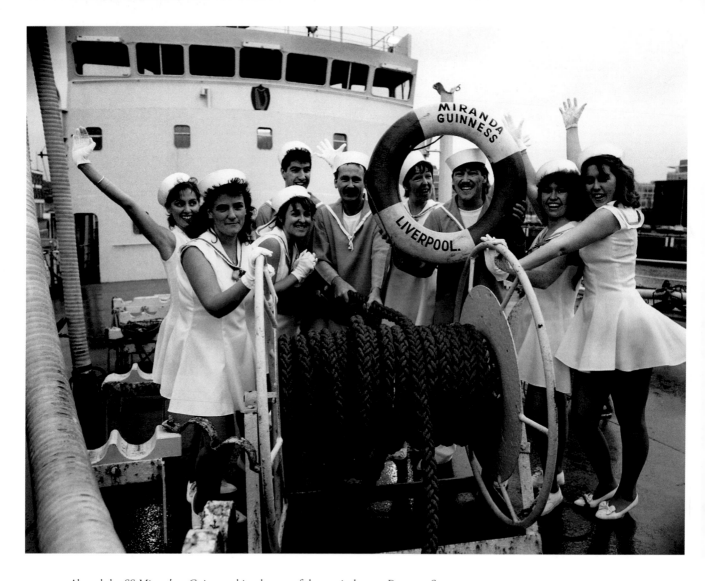

Aboard the *SS Miranda*, a Guinness ship, the cast of the musical revue *Dames at Sea* go through their paces to promote the show.

19 November 1987

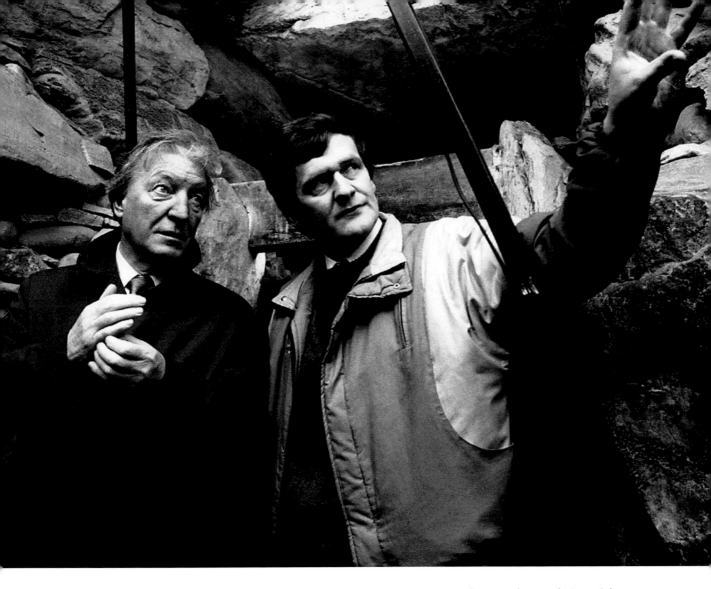

An Taoiseach Charles Haughey TD visits the Newgrange passage tomb to view the annual Winter Solstice. As the sun rises, the light traces its path along the floor of the 5,000-year-old chamber. Dr Tim O'Brien is pictured pointing out significant points of the monument to An Taoiseach.

21 December 1987

Stephen and Lydia Roche arriving at the Burlington Hotel for the thirtieth annual Texaco
Sportstars of the Year awards. Awards, presented by An Taoiseach Charles Haughey TD,
went to: athletics, Frank O'Meara; cycling, Stephen Roche; equestrian, Comdt Gerry
Mullins; Gaelic football, Brian Stafford; golf, Eamon Darcy; horse racing, Pat Eddery;
hurling, Joe Cooney; rugby, Hugo McNeill; snooker, Dennis Taylor; soccer, Liam Brady;
soccer, Hall of Fame, Danny Blanchflower.

13 January 1988

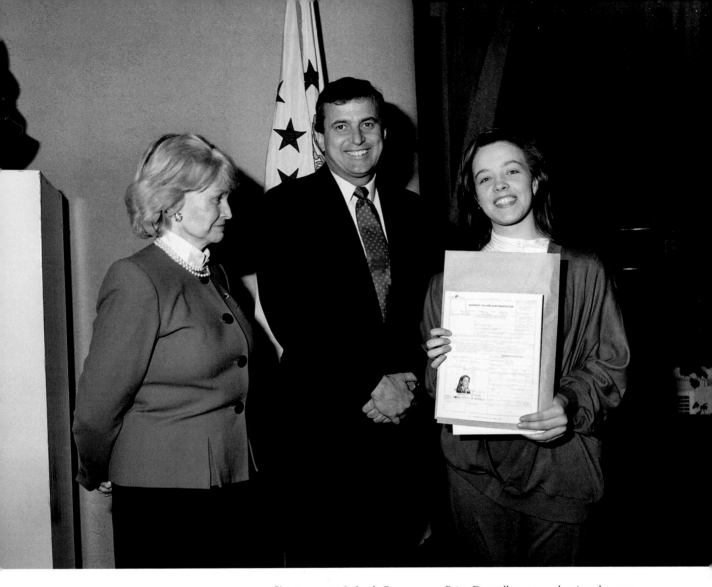

As part of his interest in Ireland, Congressman Brian Donnelly promoted a visa scheme to allow Irish people easy entry into America. The congressman came to the American Embassy in Dublin to present the new visas, known as the Donnelly visas, to those lucky enough to obtain the visas in the first draw.

19 January 1988

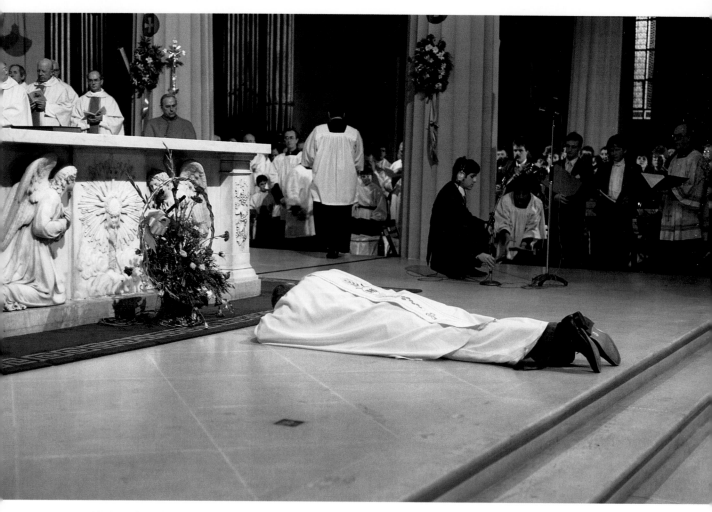

Archbishop elect of Dublin, Desmond Connell, lying prostrate before the altar
in the Pro-Cathedral during his ordination ceremony. Connell's nomination
for the position by Pope John Paul II, following the death of Archbishop Kevin
McNamara in April 1987, surprised many.

6 March 1988

Carmencita Hederman, Lord Mayor of Dublin, holds a function for centenarians
and their families in the Mansion House, Dawson Street, Dublin.

2 June 1988

Jack Charlton takes his place aboard the bus for a celebration drive through Dublin city centre, after great success in Germany in Euro '88. Fans thronged the airport and all the approach roads in the hope of seeing the team. The squad included Packie Bonner, Chris Morris, Chris Hughton, Mick McCarthy, Kevin Moran, Ronnie Whelan, Paul McGrath, Ray Houghton, John Aldridge, Frank Stapleton, Tony Galvin, Tony Cascarino, Liam O'Brien, David Kelly, Kevin Sheedy, Gerry Peyton, John Byrne, John Sheridan, John Anderson and Niall Quinn.

19 June 1988

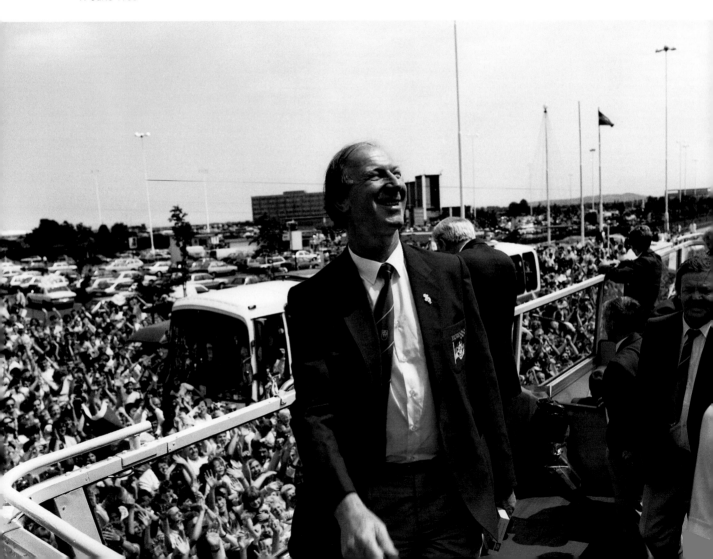

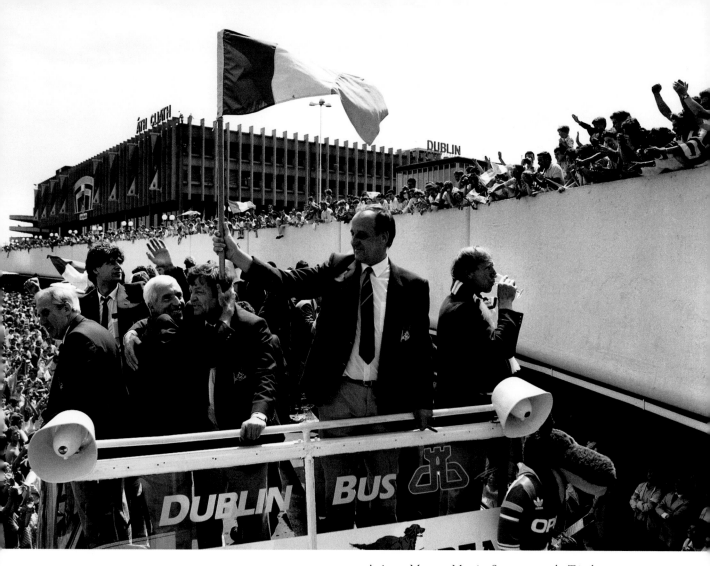

Assistant Manager Maurice Setters waves the Tricolour to a
delighted crowd as the bus sets off for Dublin city centre.

19 June 1988

155

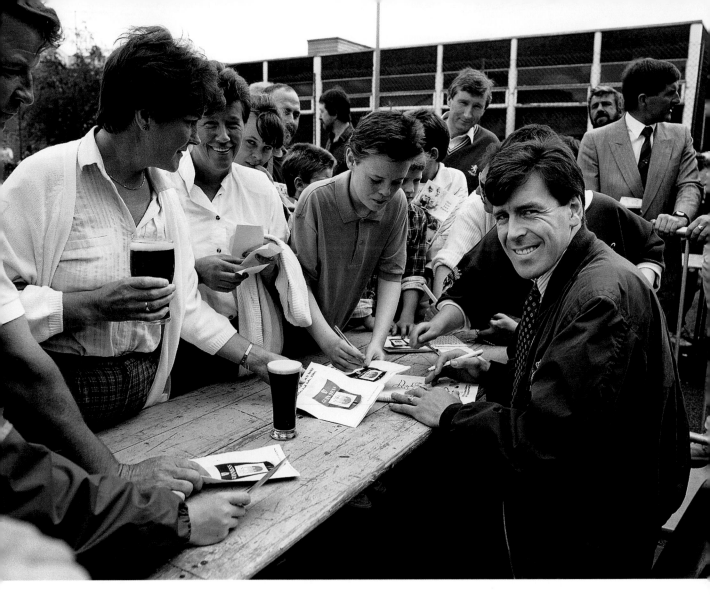

Packie Bonner signing autographs for fans at the Guinness Family Fun Day, an event for Guinness employees and their families at the Iveagh Gardens in Dublin.

2 July 1988

The Dubliners top the bill on stage at the Guinness Family Fun Day.
2 July 1988

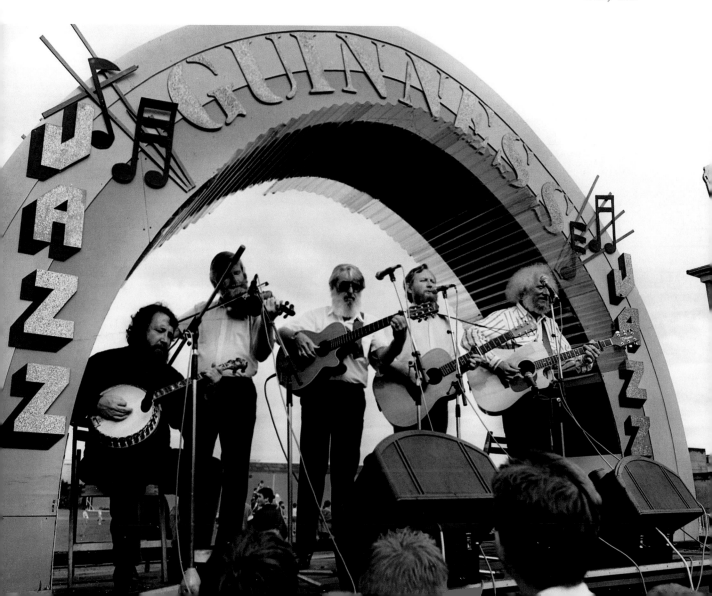

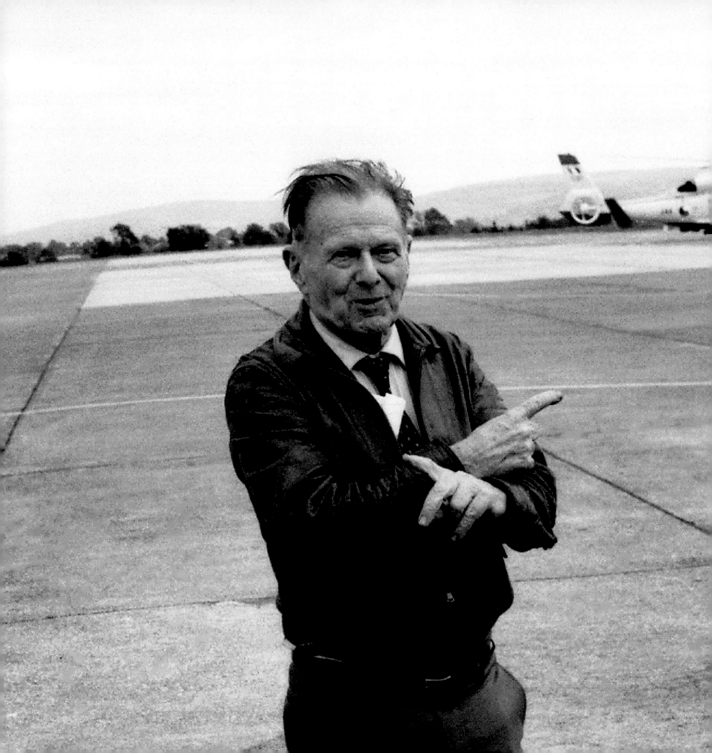

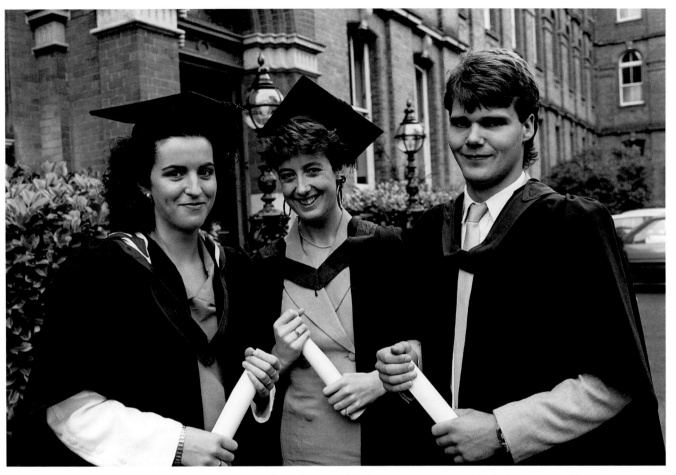

Graduation day at Carysfort College, Blackrock, County Dublin, sees the final conferring of degrees on students in the teacher training programme, after a three-year course. Marie O'Donoghue, Killarney, County Kerry, Sinead Curtin, Tralee, County Kerry, and Richard Swann, Macroom, County Cork, proudly hold their certificates.

24 July 1988

Opposite
Douglas 'Wrongway' Corrigan returns to Baldonnell Aerodrome, fifty years after his transatlantic flight in a Curtiss Robin aircraft. After a transcontinental flight from California to New York, Mr Corrigan was to make a return flight to California. However, after take off he turned and flew solo over the Atlantic to Ireland, having been refused permission by American authorities to do so. On arrival in Ireland, he maintained that bad weather conditions and compass malfunction were the reasons for his 'wrongway' flight.

18 July 1988

Three hundred Girl Guides at Larch Hill. As part of their Diamond Jubilee celebrations, the Girl Guide movement organised a friendship camp in the grounds of Larch Hill, Tibradden, County Dublin, for 300 girls. Physical activity is part and parcel of a busy day, and here some of the guides attack the obstacle course.

25 July 1988

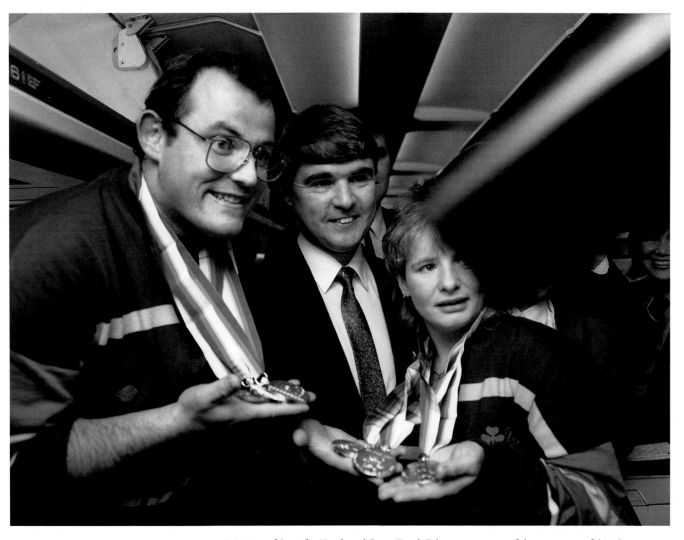

Minister of State for Youth and Sport Frank Fahey meets some of the very successful Irish Paralympic team as they arrive home to Dublin from the Games at Seoul, South Korea. The team managed an impressive haul of forty-two medals – thirteen gold, eleven silver and eighteen bronze – earning them nineteenth place in the overall medals table.

28 October 1988

Gordon Wilson, Maureen O'Mahony and Jack Charlton were among the award winners at the fourteenth People of the Year Awards at the Burlington Hotel, Dublin. The others were: Ollie Jennings, Carmencita Hederman, Tommy Boyle, Alice Leahy and Norma Smurfitt.

22 November 1988

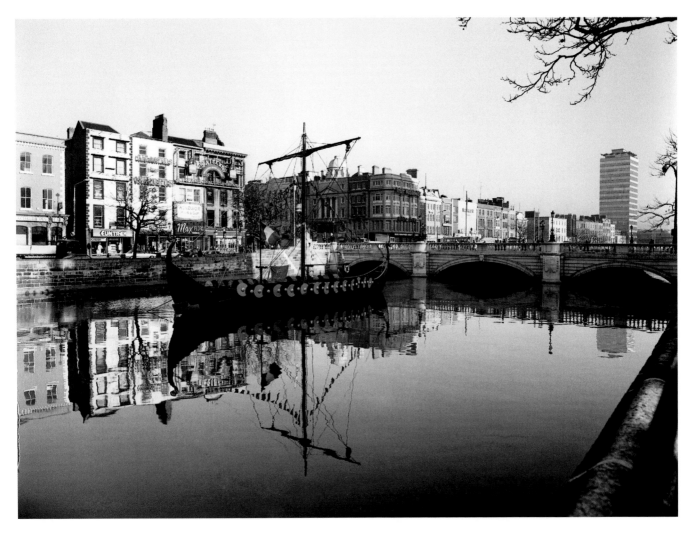

As part of the Millennium celebrations in Dublin, a Viking longboat sailed up the Liffey and moored at O'Connell Bridge. The finding of the Viking settlement at Wood Quay shows the depth of Dublin's Viking heritage.

24 November 1988

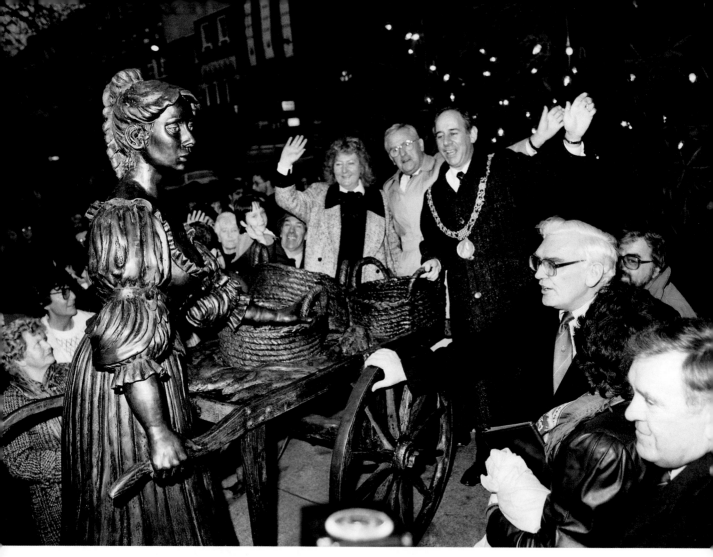

'Dublin's Fair City' receives a millennium gift to commemorate her most famous daughter, Molly Malone, as Jury's Hotel Group plc presents a specially commissioned sculpture to the people of Dublin. In the shadow of the Christmas tree, Lord Mayor Ben Briscoe TD, Michael McCarthy, MD of Jury's Hotel Group, and Dublin-born artist Jeanne Rynhart wave to the cameras at the official unveiling of 'Molly Malone'.

20 December 1988

Phyllis Nolan, the first female Garda to reach the rank of Superintendent, pays a courtesy call to An Taoiseach Charles Haughey TD. She is pictured here with Gerry Collins TD, Minister for Justice, An Taoiseach Charles Haughey TD and Garda Commissioner Eugene Crowley, at the office of An Taoiseach in Government Buildings.

21 February 1989

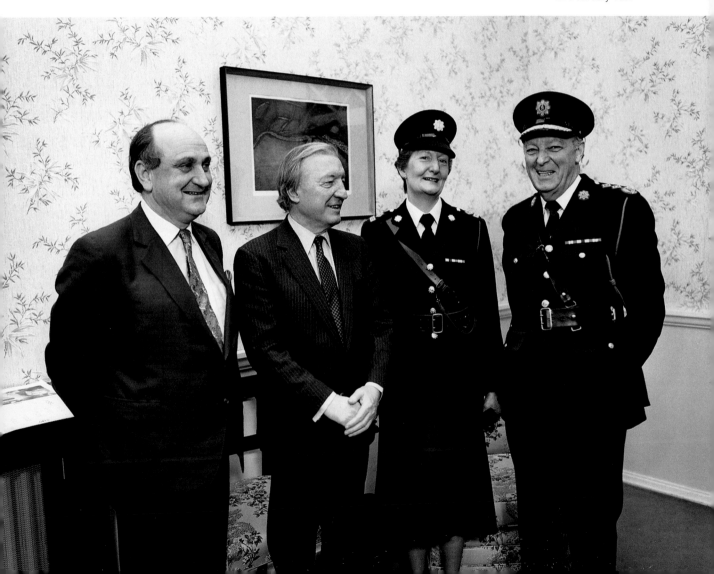

The Blood Transfusion Service launches the country's first bone marrow and platelet register, intended to provide tissue-typed potential donors for designated bone marrow transplant units at St James's Hospital and Our Lady's Hospital, both in Dublin, to bring hope to those who suffer from leukaemia and other blood disorders. U2's Larry Mullen Jr was there to help mark the event.

1 March 1989

Opposite

While serving on the peacekeeping mission with the UN in Lebanon, three Irish soldiers lost their lives when their vehicle struck a land mine, planted by a Hezbollah group who were targeting the Israeli military. The coffins of Corporal Fintan Heneghan, Private Mannix Armstrong and Private Thomas Walshe, serving with C Company, 64th Infantry Battalion, lie in state in Arbour Hill Church, Dublin.

24 March 1989

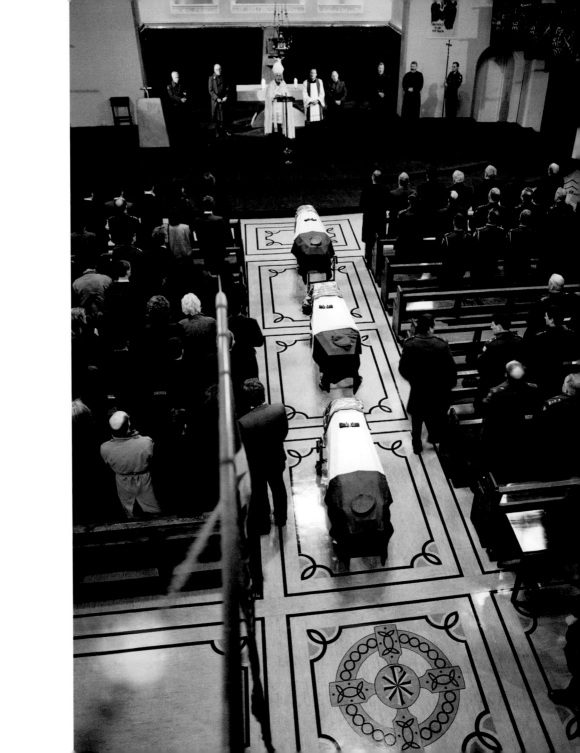

Raisa Gorbachev visits Bunratty Folk Park, accompanied by Maureen Haughey, wife of An Taoiseach Charles Haughey TD. While her husband, Russian President Mikhail Gorbachev, was working on state matters, Mrs Gorbachev was taken on a tour of the Folk Park in County Clare. The Gorbachevs were in Ireland as part of a tour of European capitals.

2 April 1989

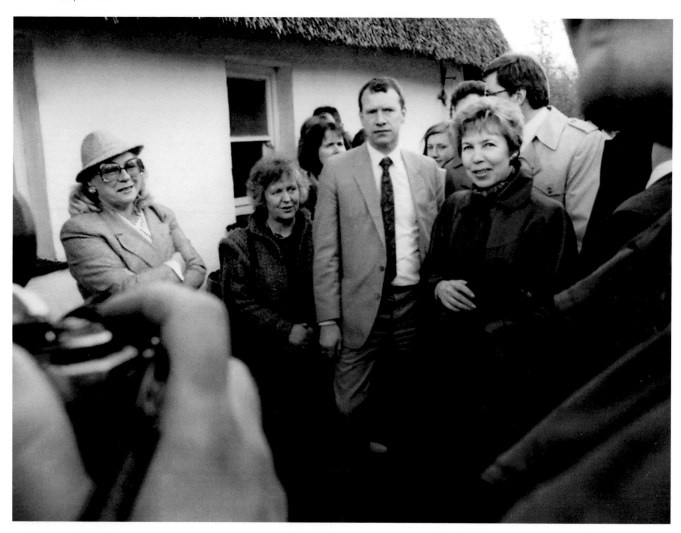

World Champion bowler, Bill Daly of Cork, demonstrating the skills which made him a champion, at the first Dublin road bowling tournament, run by Bol Chumann Na hÉireann in aid of Cerebral Palsy Ireland. The tournament ran through the Phoenix Park in Dublin, for a distance of two miles. Armagh and Cork challenged each other for a new perpetual trophy, the 'Super Bol'.

3 April 1989

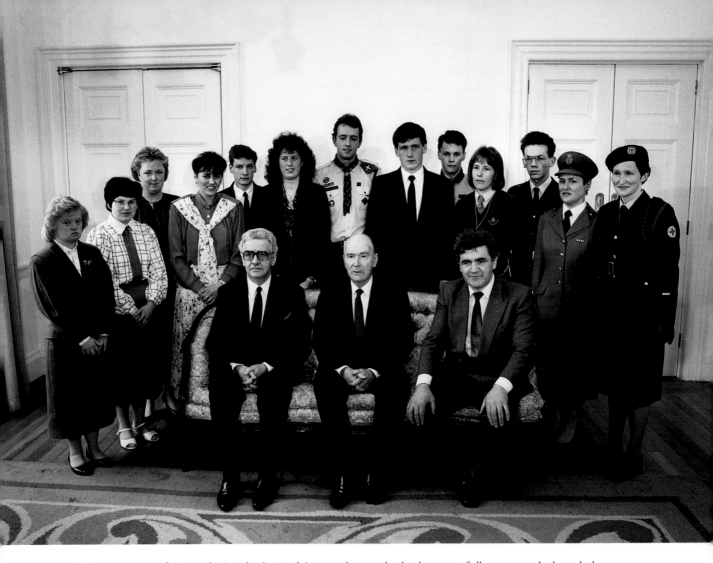

The presentation of Gaisce, the President's Award, 'to contribute to the development of all young people through the achievement of personal challenges', at the Royal Hospital, Kilmainham, Dublin. Standing are the award winners: Jacinta O'Neill, Linda Henry, Catherine Butler, Sally McGroarty, Derek Brannigan, Mary McCarthy, James Roycroft, Joseph Treacy, Kenneth Purcell, Martina Breen, Derek McInerney, Majella Killeen and Carolyn Hurley. Seated are Justice Liam Hamilton, President Dr Patrick Hillery and John Murphy, Executive Director of Gaisce.

10 April 1989

The Mosney Holiday Express, about to set off from Connolly Station, Dublin, for its run to Mosney Holiday Camp, County Meath. The express was sent on its way by Snow White (Lorraine McCourt), who had left the seven dwarfs at the Olympia Theatre in Dublin.

27 April 1989

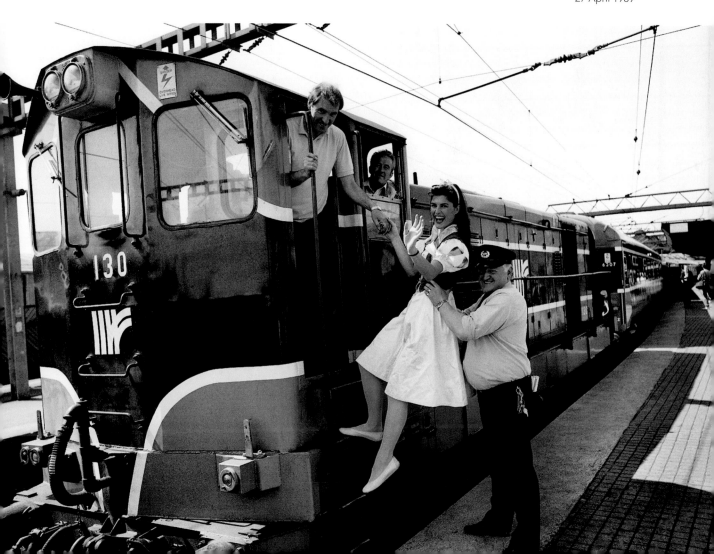

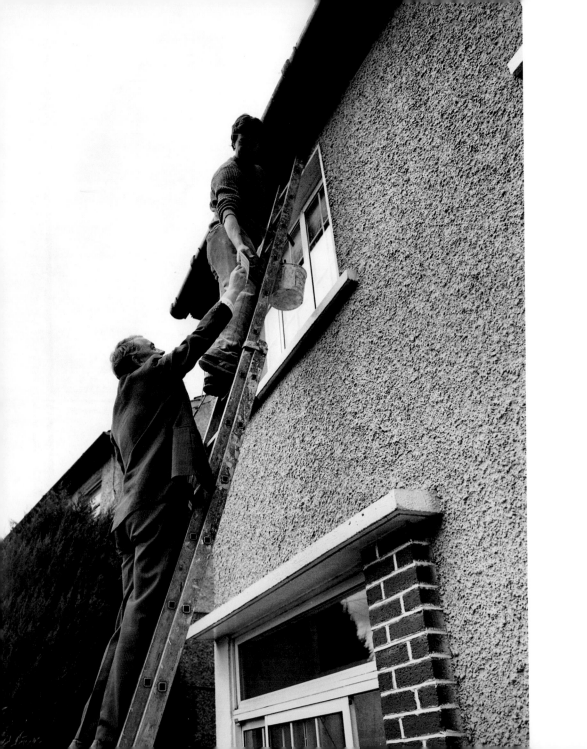

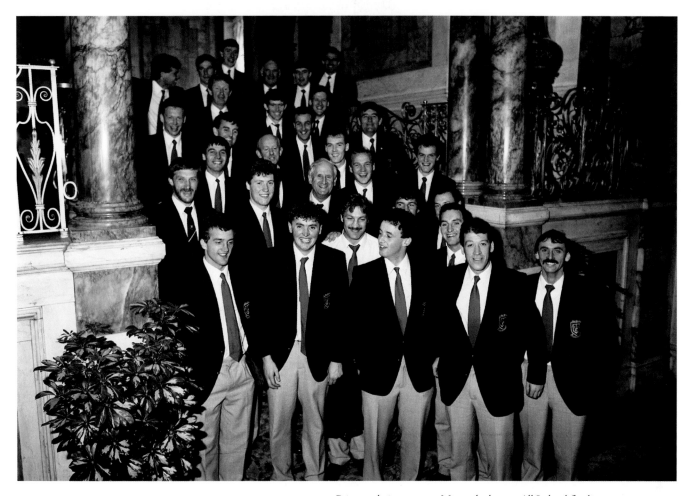

Prior to their return to Mayo, the beaten All Ireland finalists pay a
courtesy call to the Department of Foreign Affairs at Iveagh House in
Dublin. Mayo had been beaten by Cork in a thrilling final the previous
afternoon in Croke Park.

18 September 1989

Opposite
Austin Currie going to great heights to meet John Doyle as he canvasses in
Palmerstown, in his quest to win a seat for Fine Gael in the General Election.
Currie, a founder member of the SDLP, previously held a seat in the Northern
Ireland Executive, serving as Minister for Housing and Local Planning.

7 June 1989

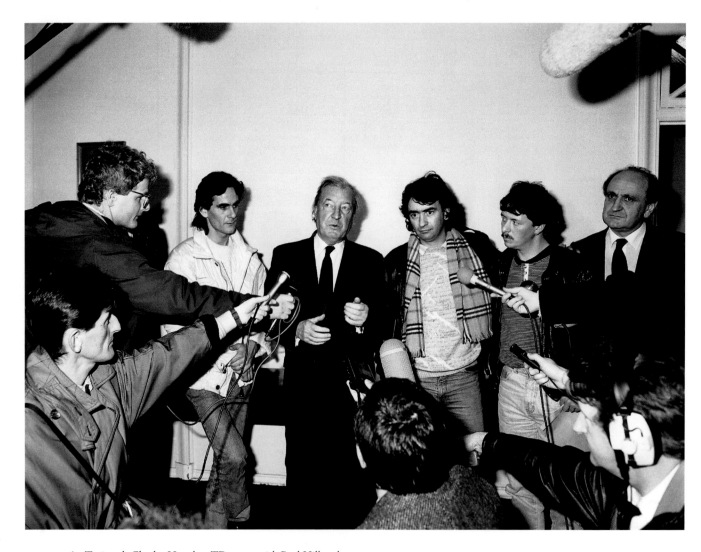

An Taoiseach Charles Haughey TD meets with Paul Hill and
Gerard Conlon, two of the Guildford Four. Having been
wrongly convicted of a pub bombing, the Four were finally
released on appeal after fourteen years in prison. Having been
offered no compensation for their time in prison, they met with
An Taoiseach to highlight the injustices they had suffered.

3 November 1989

Ireland midfielder Liam Brady models a World Cup 'Italia '90' sweatshirt, produced to celebrate qualification for the World Cup in Italy. Thousands of Irish fans made the journey to follow the 'boys in green' in their quest for World Cup glory.

6 December 1989

Also available

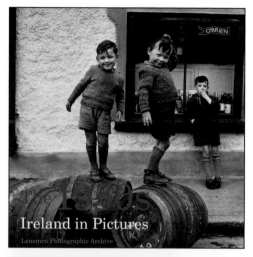

Ireland in Pictures
Lensmen Photographic Archive

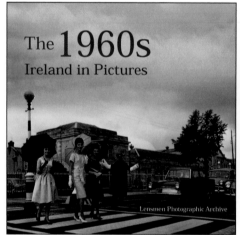

The **1960s**
Ireland in Pictures

Lensmen Photographic Archive

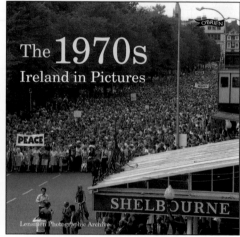

The **1970s**
Ireland in Pictures

Lensmen Photographic Archive